D. SHRIGLEY

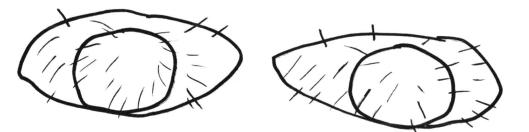

HAIR GROWING ON YOUR EYES

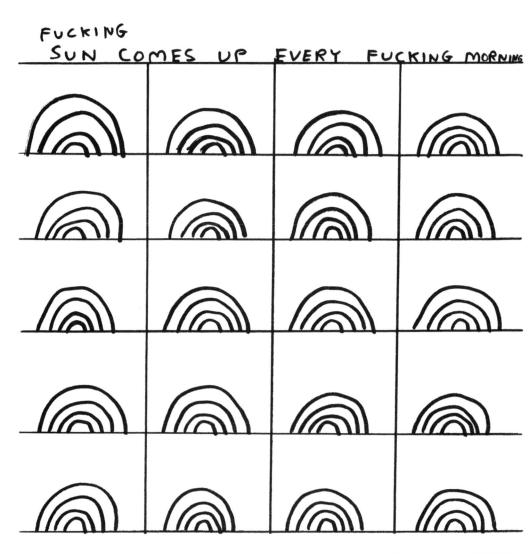

First published in the United Kingdom in 2009 by Redstone Press, 7a St. Lawrence Terrace, London, W10 5SU www.redstonepresss.co.uk www.theredstoneshop.com

Layout: Kim McKinney Production: Tim Chester Manufactured in China by C & C Offset Printing

ISBN 978-1-870003-34-6

A CIP record for this book is available from the British Library

© David Shrigley 2009

David Shrigley has asserted his right under the Copyright, Design and Patent Act, 1988 to be identified as the author of this work.

All Rights Reserved. No part of this publication may be reproduced or transmitted in any form or by any means, electronic or mechanical, including photocopy, recording, or any other information storage and retrieval system, without prior permission in writing from the publisher.

This book was created during a residency at IASPIS, Stockholm, April–May 2009.

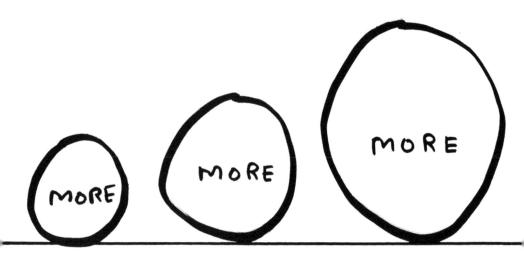

EAMHABITY

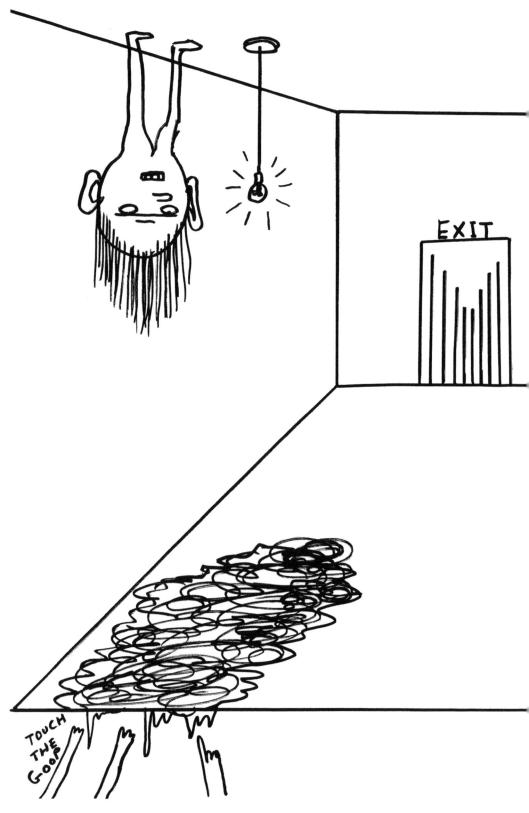

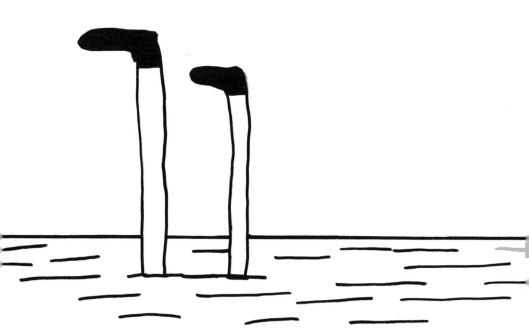

- I HAVE FALLEN FROM A
- GREAT HEIGHT
- INTO THIS PUDDING
- BUT DON'T WORRY
- I AM O.K.

	WORDS	WORDS	WORDS	WORDS	WORDS	WORDS	WORDS	WORDS	WORDS	WORDS	WORDS	WORDS	
\int	WORDS	WORDS	WORDS	WORDS	MORDS	W ORDS	WORDS	WORDS	WORDS	WORDS	WORDS	WORDS	
\int	WORDS	WORDS	WORDS	WORDS	WORDS	WORDS	W OR DS	WORDS	WORDS	WORDS	WORDS	WORDS	

INTERESTS

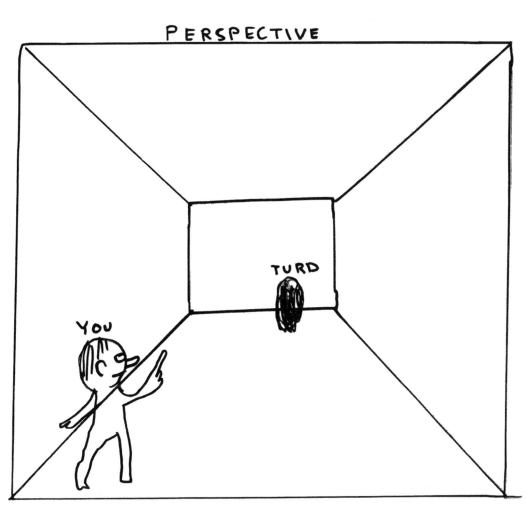

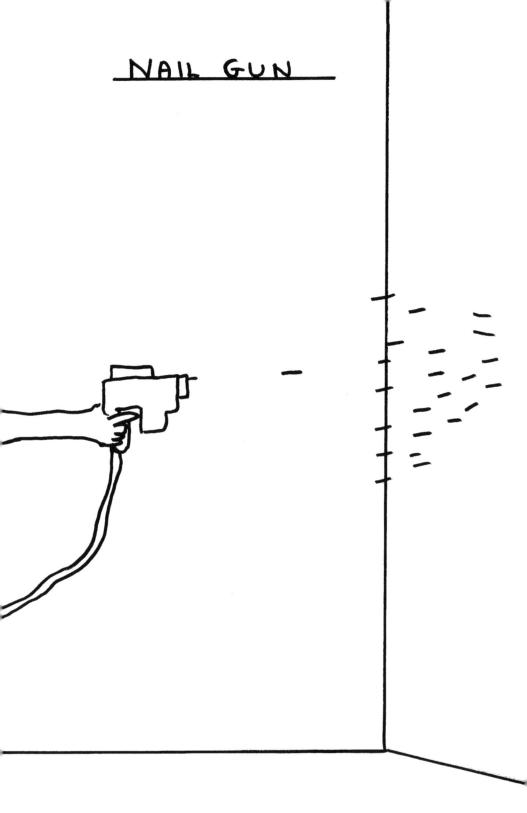

EYE COUNT

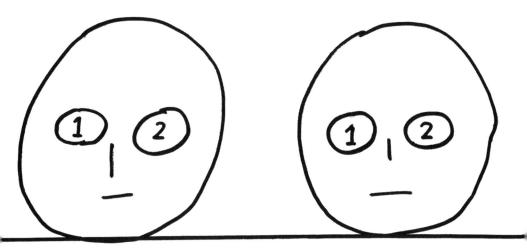

PHOTOGRAPHS

I FIX YOUR BRAIN

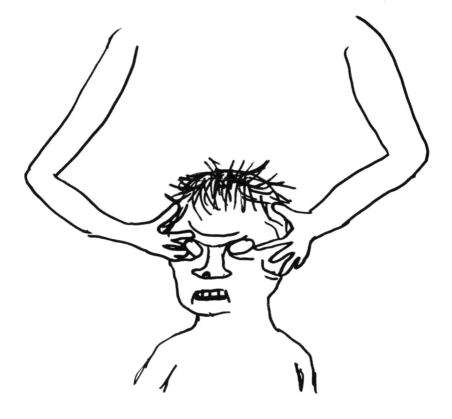

DEATH DOOM DIE DISEASE DISINTEGRATION DEGRADATION DISAFFECTION DOG SHIT DIRE DISFUNCTIONAL DELICATESSEN

WHY NOT HUNGRY?	WHY NOT TRADITIONAL MEAL ? IS DELICIOUS	TRADITIONAL MEAL ?
SMELL OF MELTED	NOT HUNGRY	NO THANK-YOU

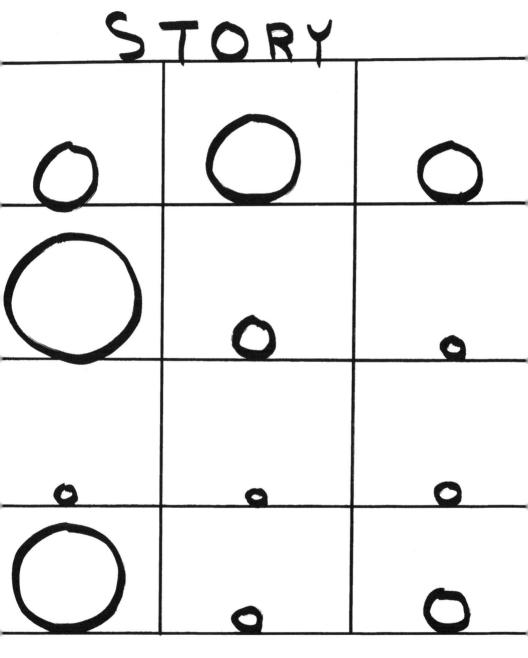

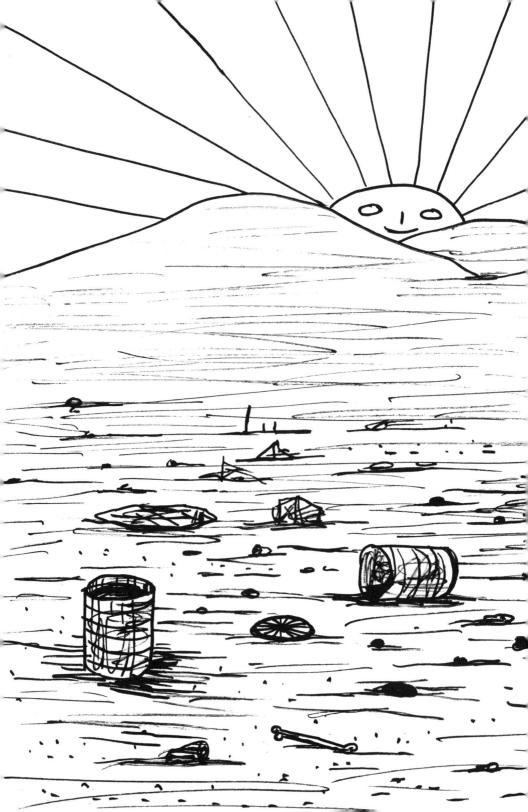

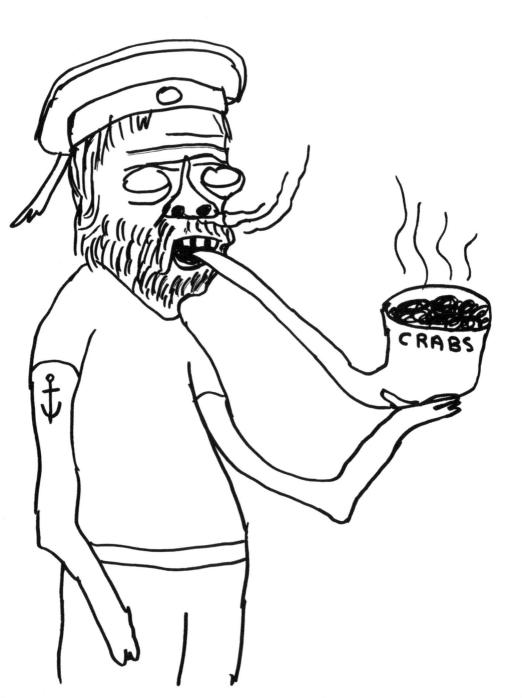

OUTDOOR SWIMMING POOL

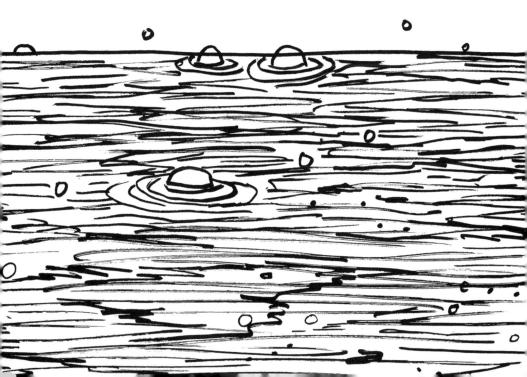

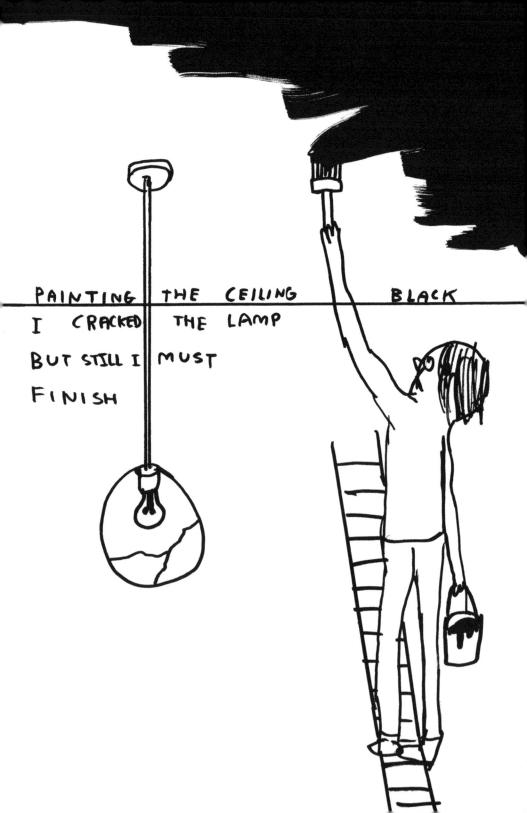

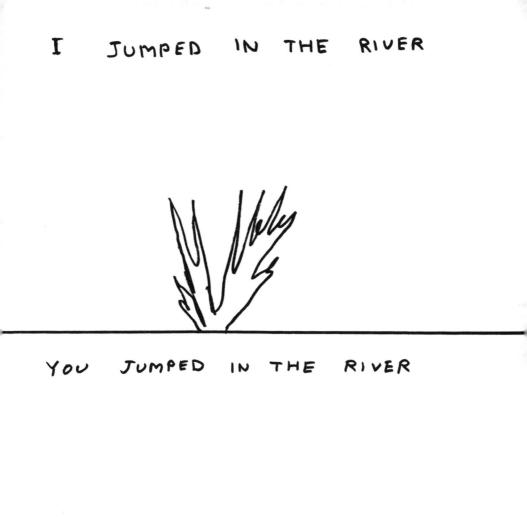

I DID NOT INTEND FOR YOU TO JUMP IN THE RIVER

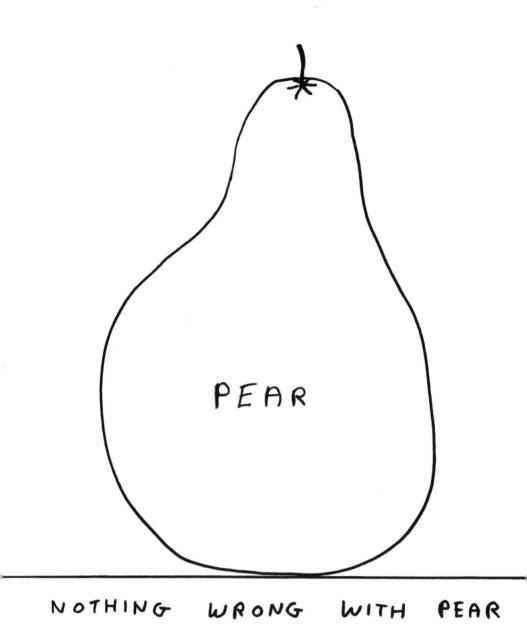

I LOST MY EAR

IT IS POSSIBLE THAT I MIGHT GET IT BACK BUT I DON'T KNOW

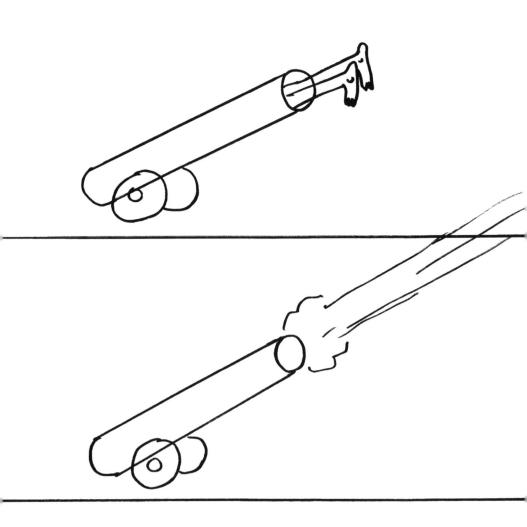

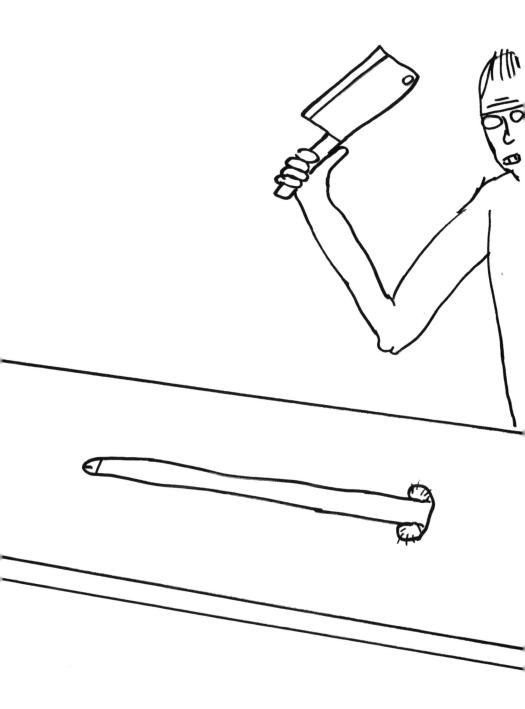

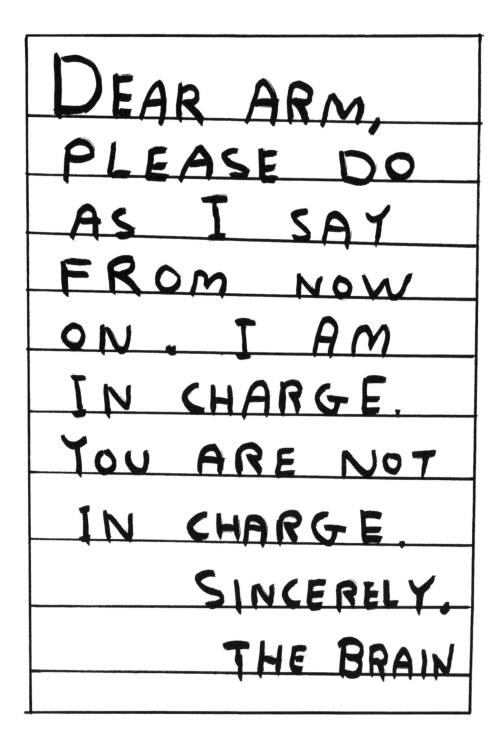

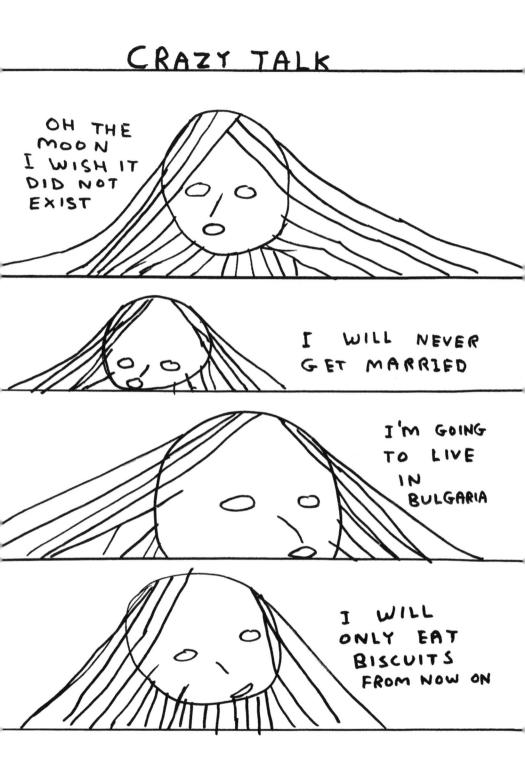

DROOL FOR PEACE

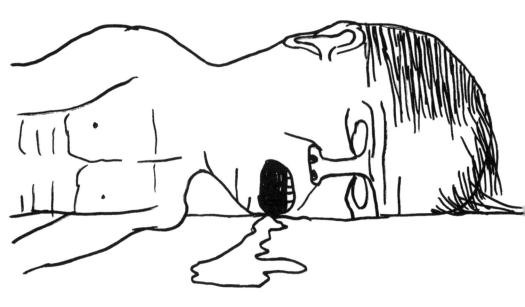

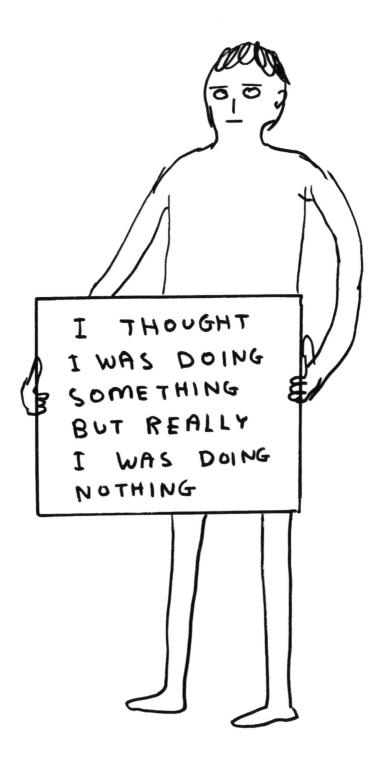

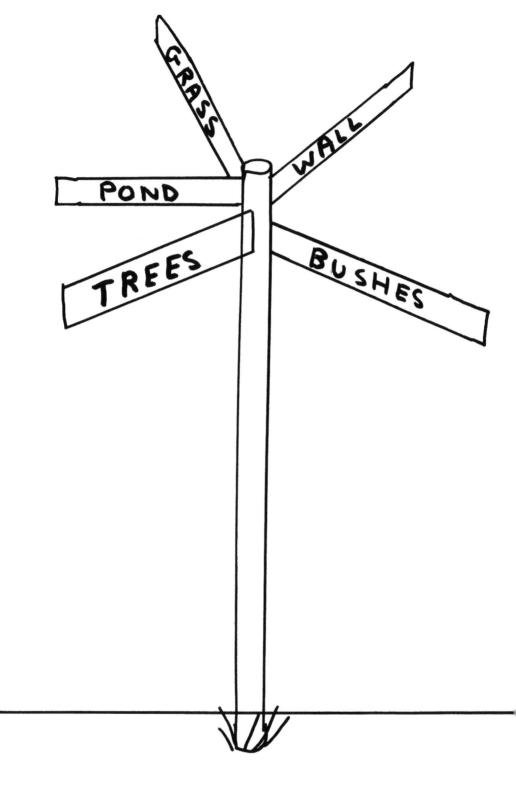

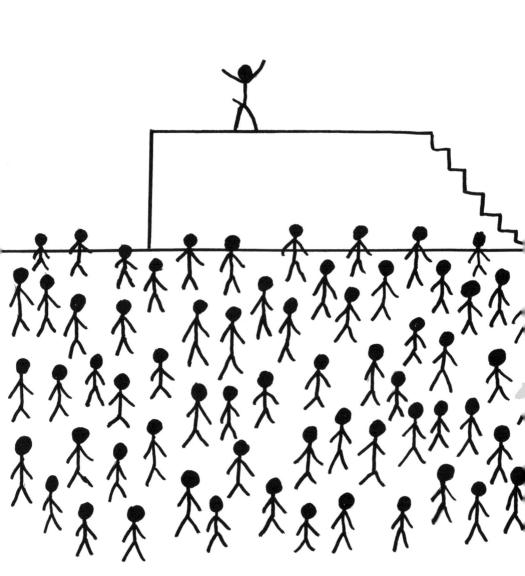

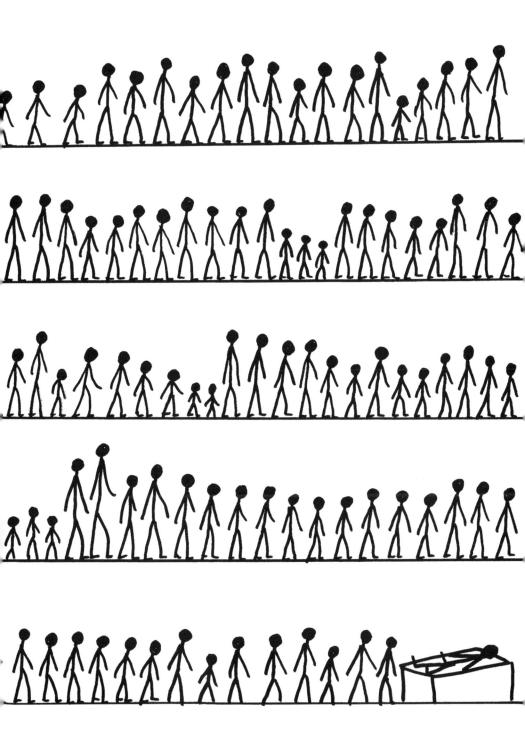

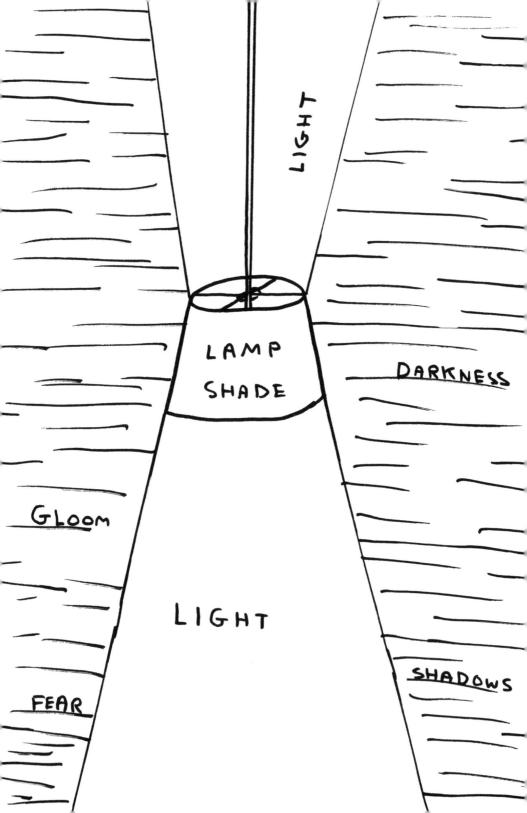

FRIENDS FRIENDS

ENEMIES ENEMIES ENEMIES ENEMIES ENEMIES ENEMIES ENEMIES ENEMIES EN EMIES EN EMIES EN EM IES ENEMIES ENEMIES ENEMIES ENEMIES ENEMIES ENEMIES ENEMIES ENEMIES ENEMIES

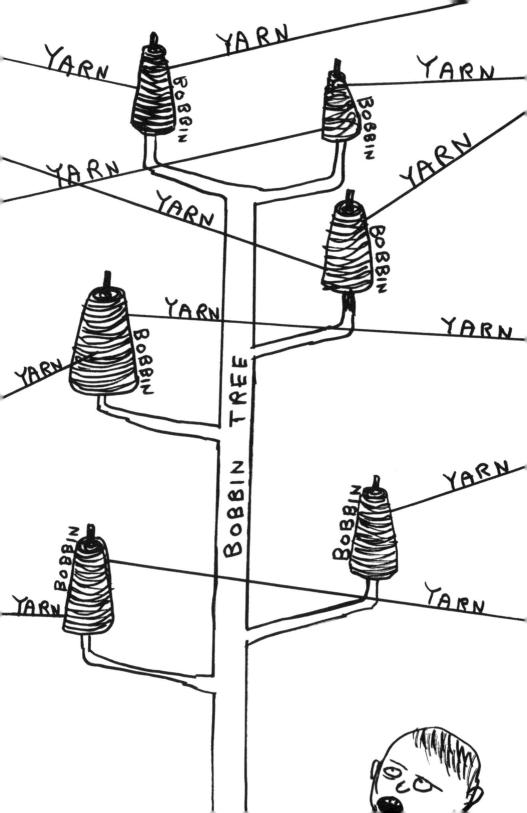

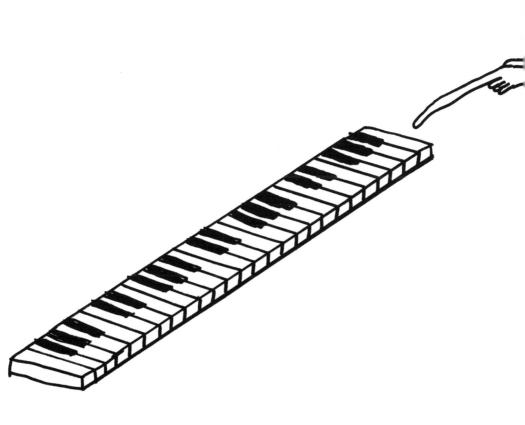

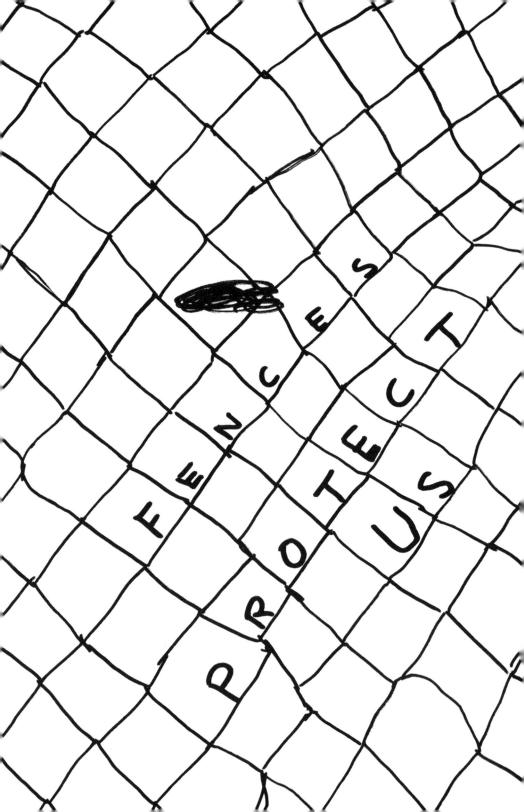

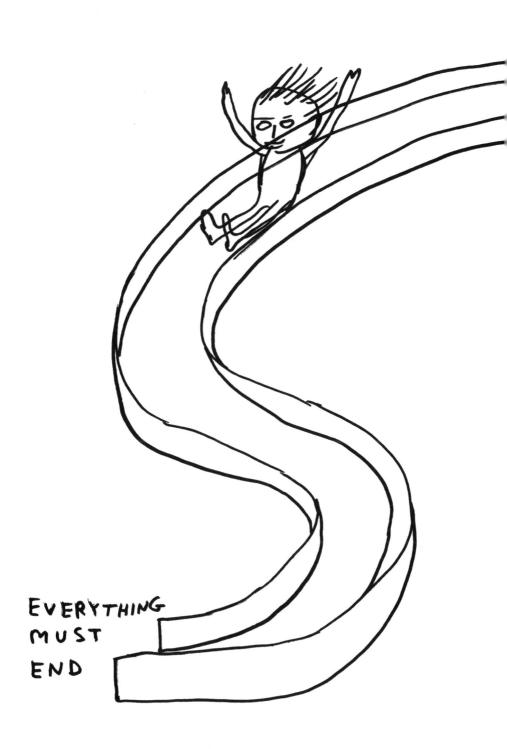

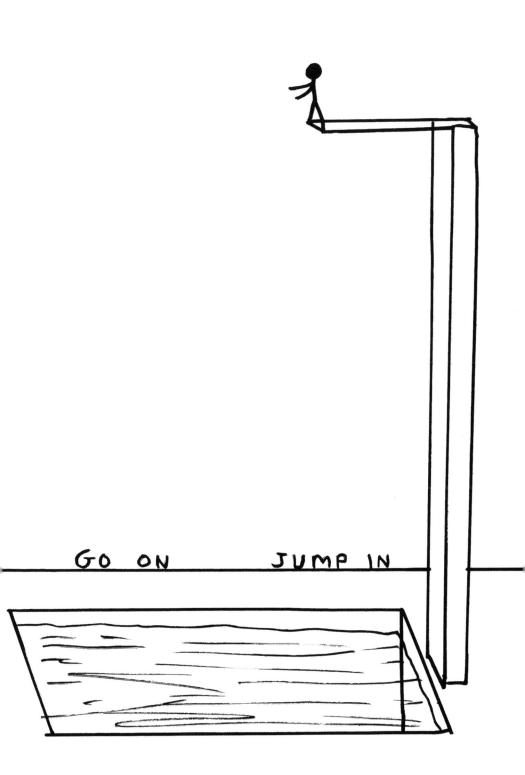

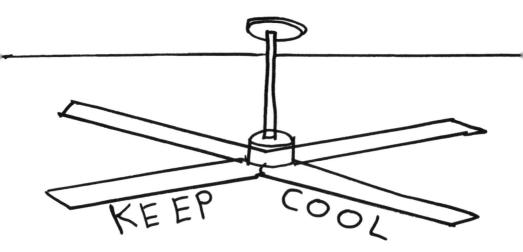

DON'T GET HOT

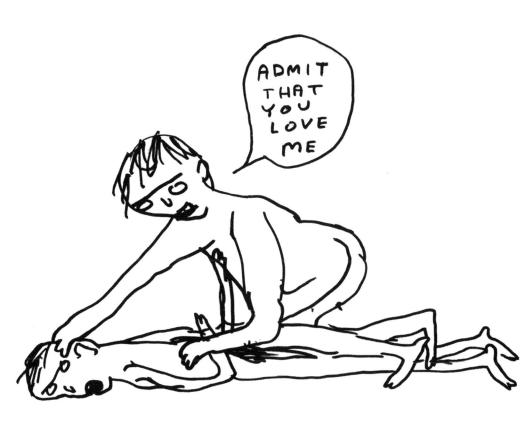

SWIPE YOUR CARD

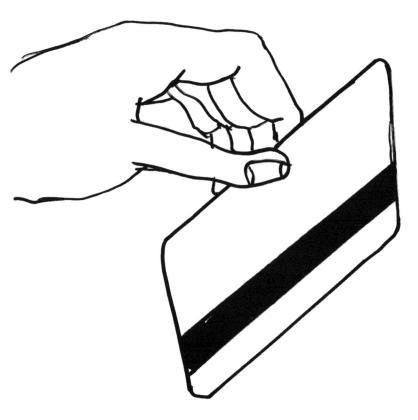

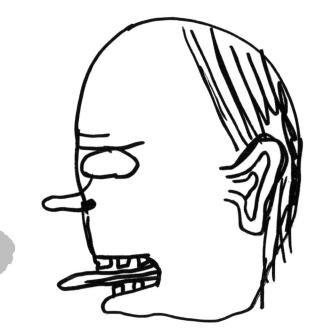

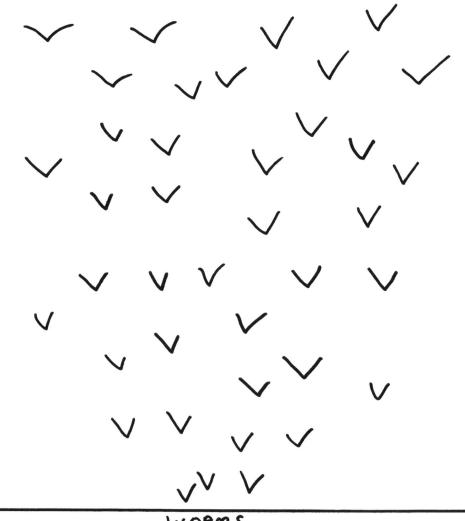

WORMS

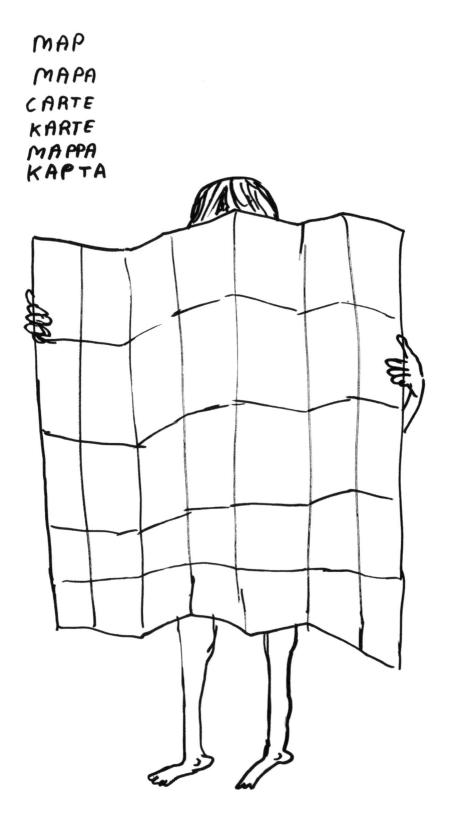

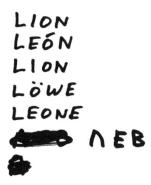

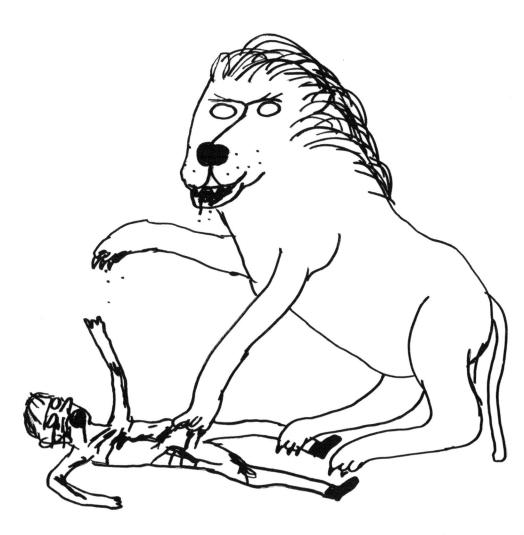

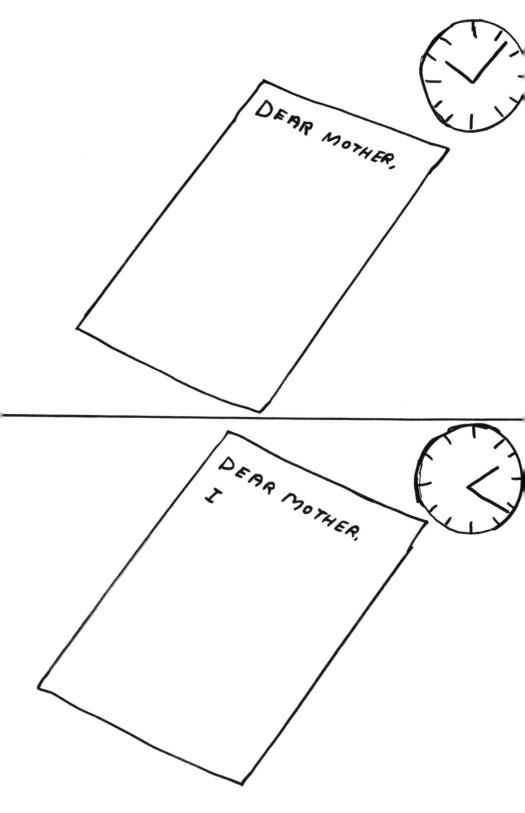

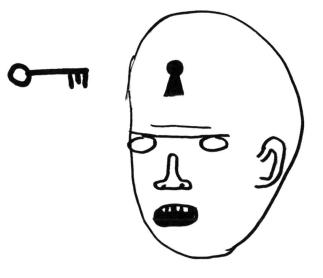

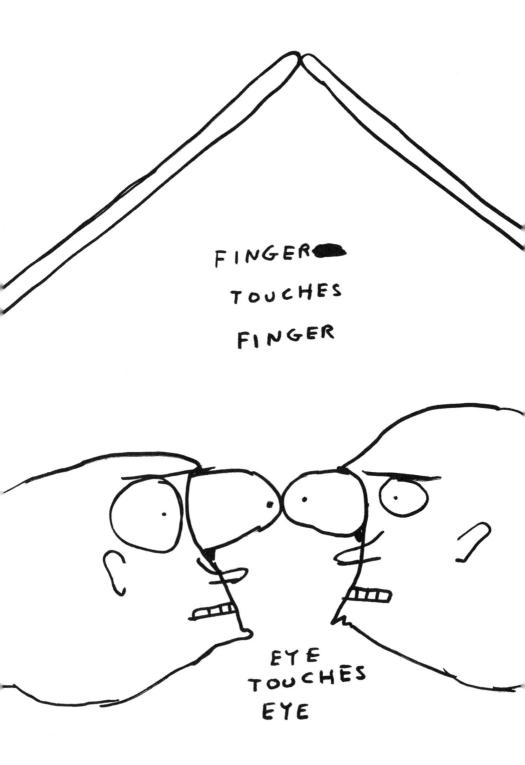

BIRTHING SPOON

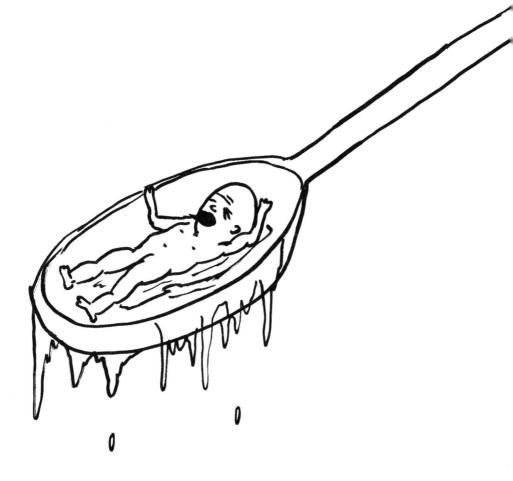

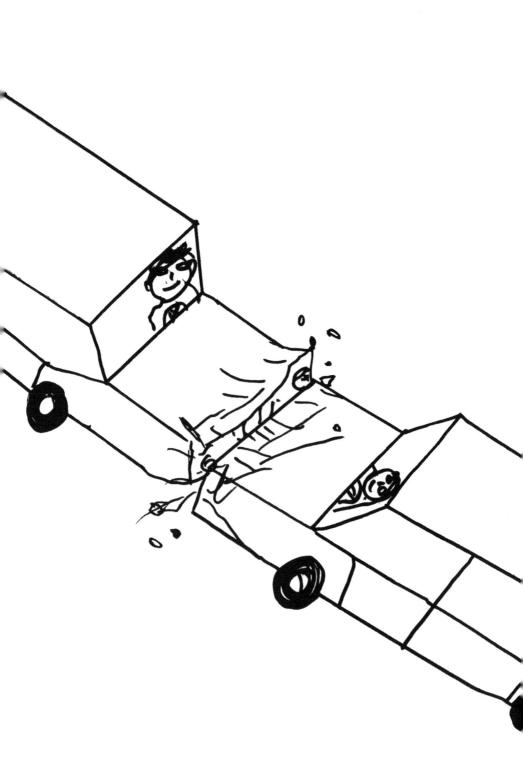

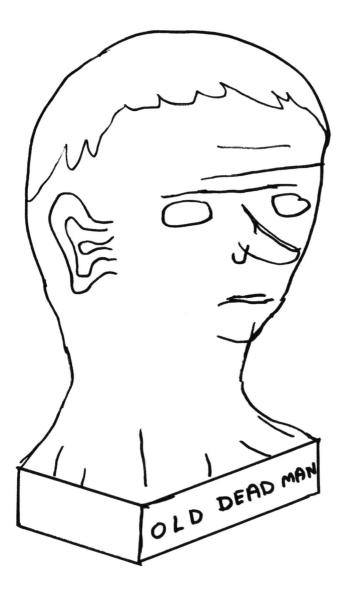

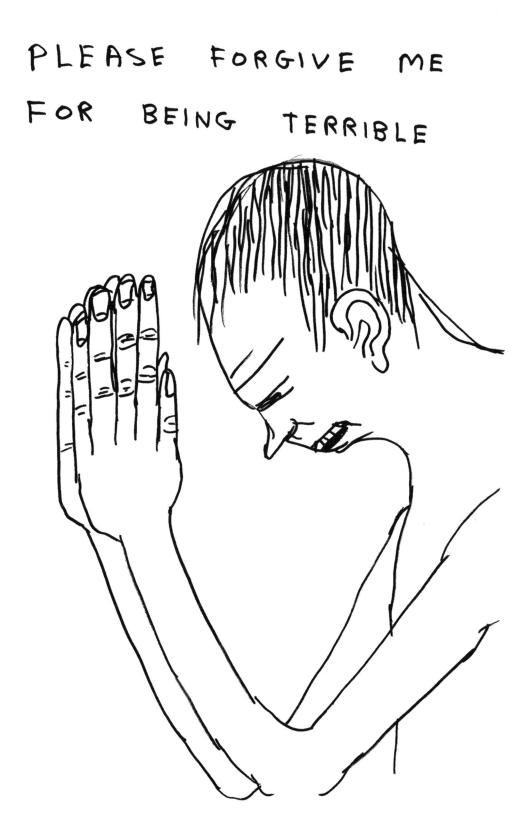

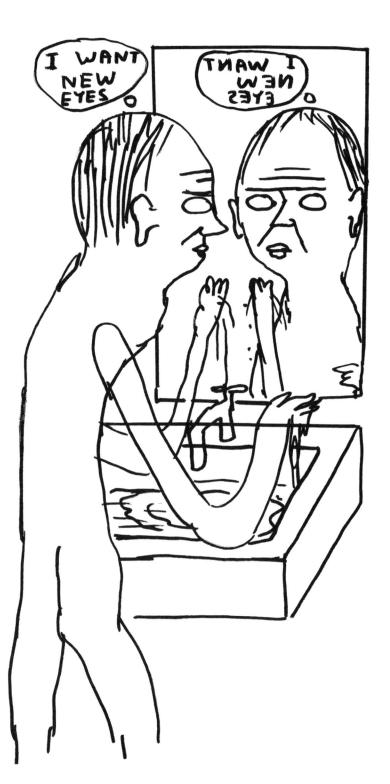

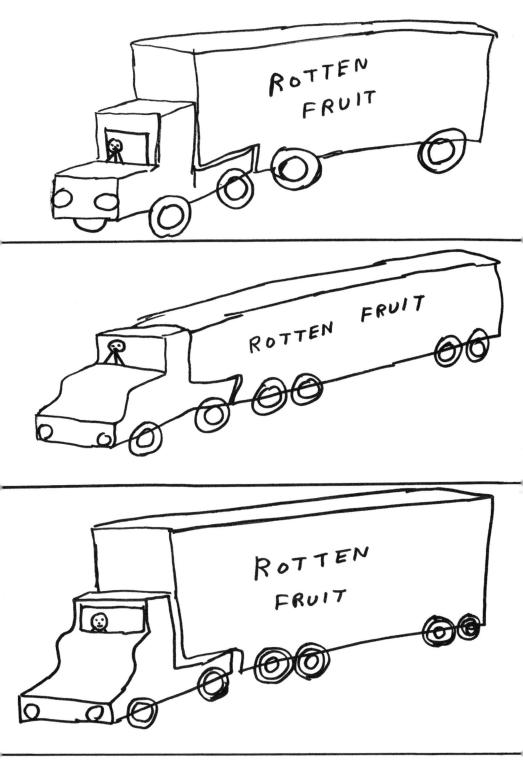

IT KEEPS COMING

9

YES

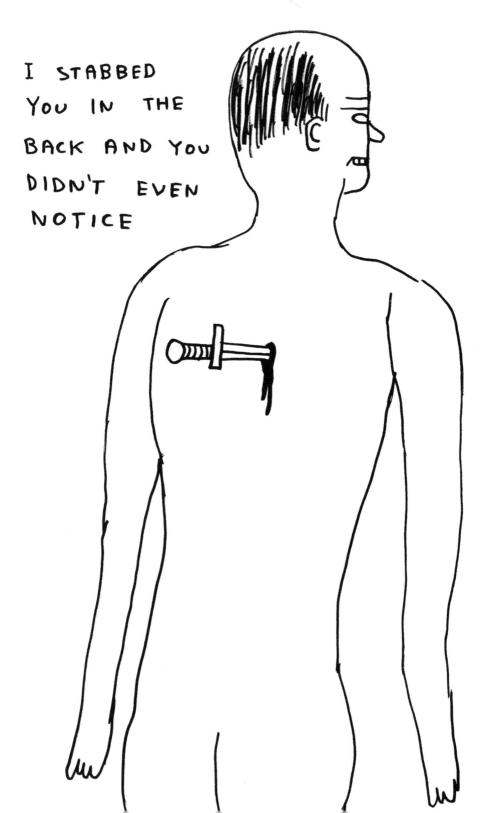

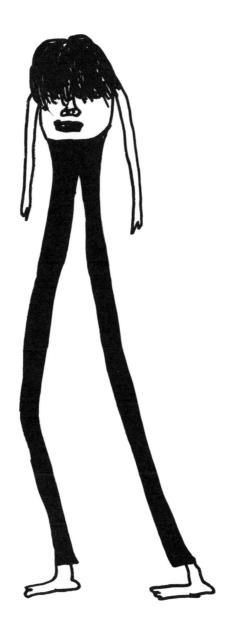

TEEN -AGER

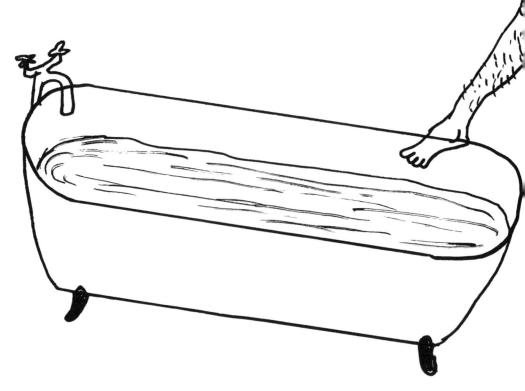

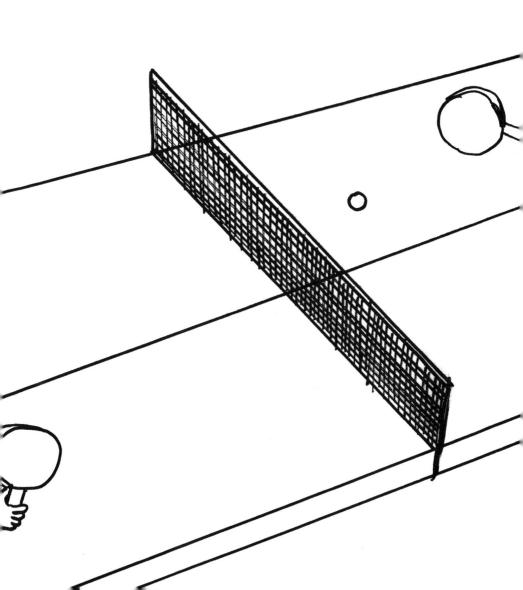

THE GATES

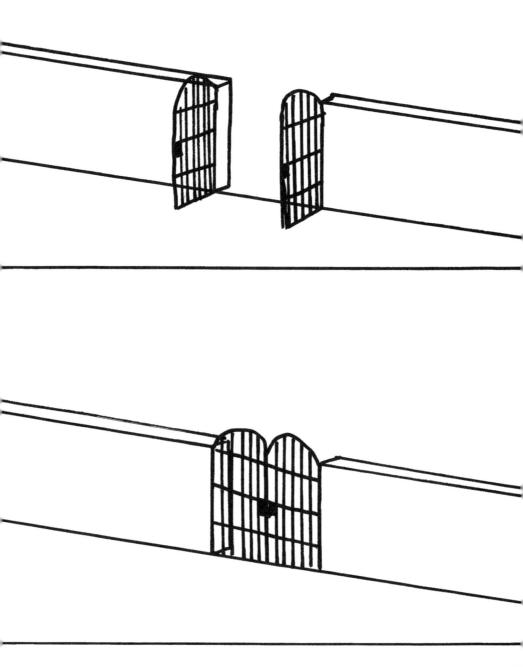

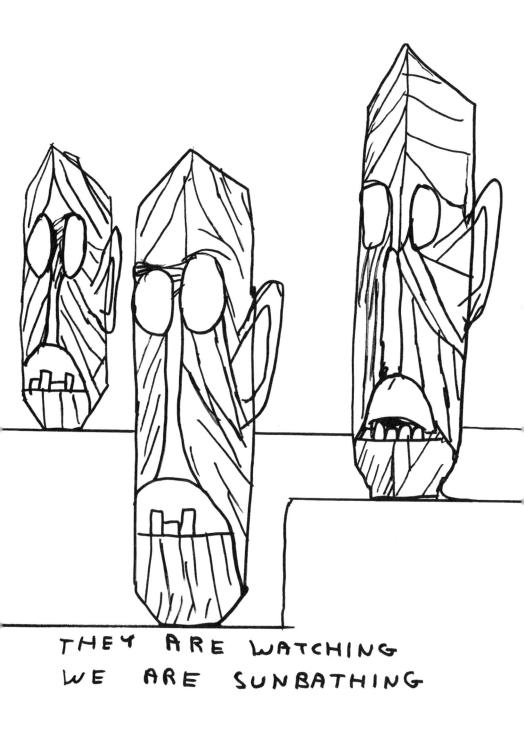

IT IS MINE

- PLEASE REMOVE IT FROM THE PASSAGE
 - I CANNOT
- WHY NOT ?

BECAUSE IT IS A LIVING THING WITH ITS OWN WILL AND REFUSES TO BE MOVED

FUTURE OF THE EGG

I AM OPTIMISTIC ABOUT THE

FUCK OFF

SIX LUMPS OF SUGAR IN

ONE CUP OF TEA FIFTY CUPS LIKE THIS PER DAY DON'T TELL ME I CAN'T

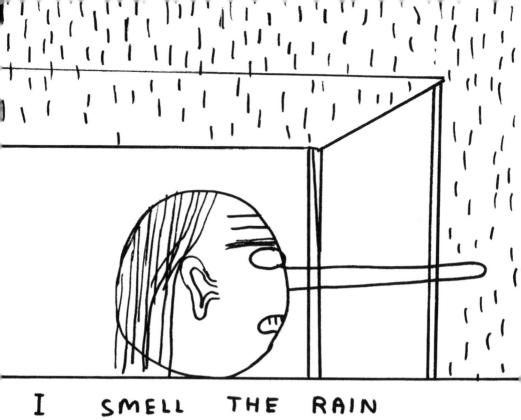

THE RAIN SMELLS HORRIBLE

ОННКННН АНН ОННИ ООООНН ОНИ АННН АННННИНННН АНННИНИННИН	Аннн онн ооон
Аннн онн оннн ооонн Анн оонннннн Ан	00000нн оннн оннннннн он нн нннн он н н н н н
АННННННН АААННН ННН АААННН ААН АН АНННННННН	онннннннн Онннннннн он нн нн нн он н н нн нн он н н нн нн оо оо

- MY PONCHO WAS COVERED
- IN BLOOD

- HIS PONCHO WAS COVERED
- IN BLOOD

PLEASE DON'T LEAVE THE FUN HAS JUST STARTED

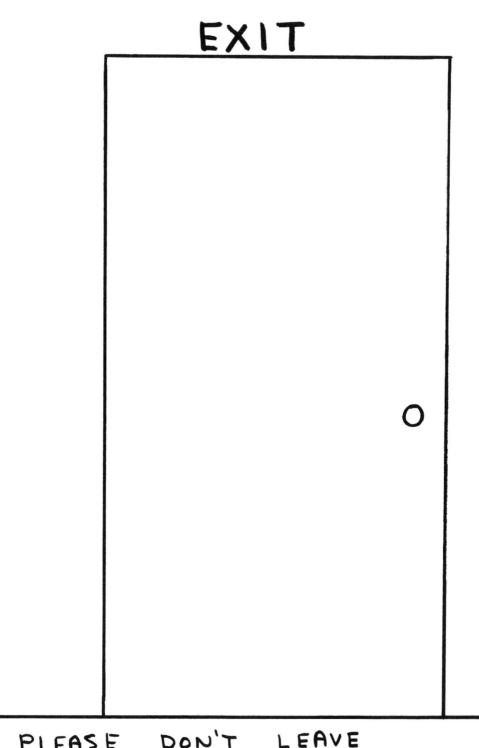

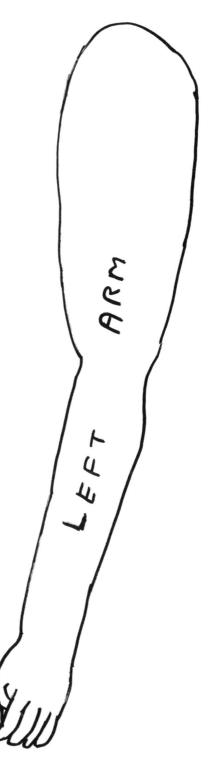

I PISS ON THEM EVERY DAY

IT SPINS AROUND

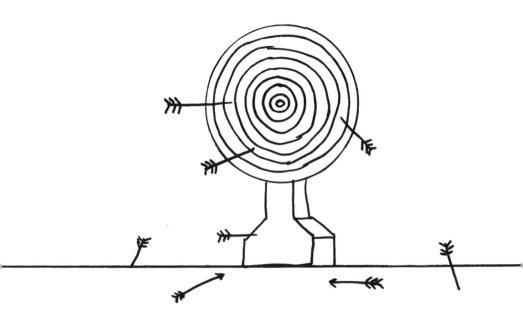

DAWN AHHH Z AHHH

I'VE BEEN

DANCING A MEANINGLESS DANCE WITH STRANGERS

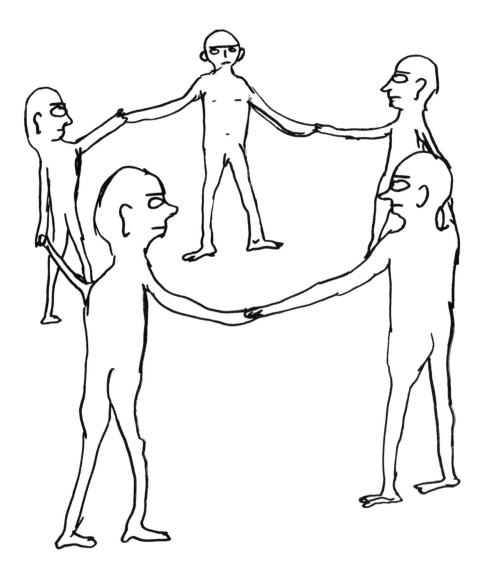

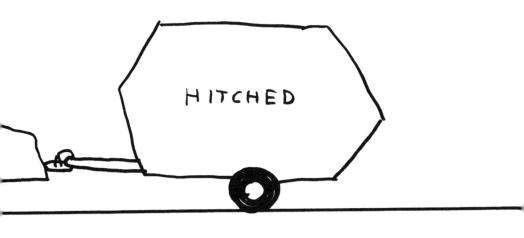

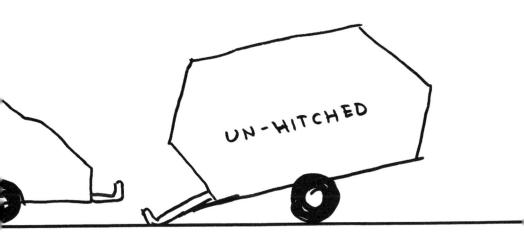

MY LOAD WEARS A BLACK HAT I AM TO PLACE IT UPON HIS HEAD WHEN THE TIME COMES

FORBIDDEN

BANANAS

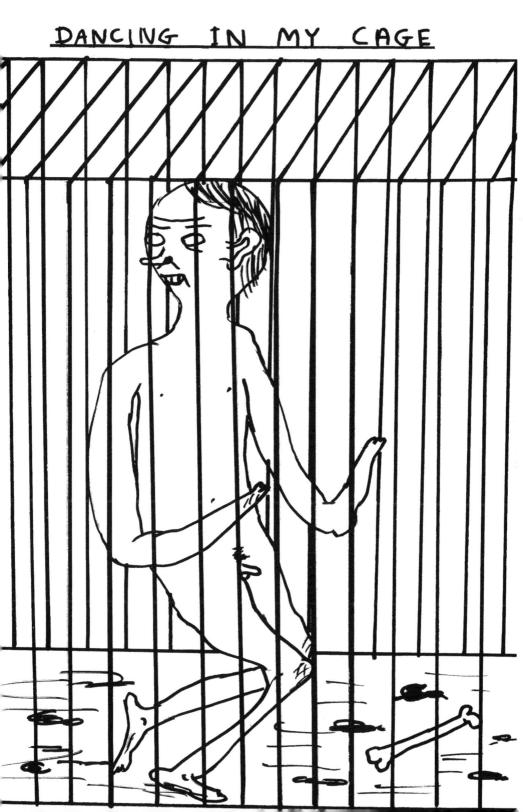

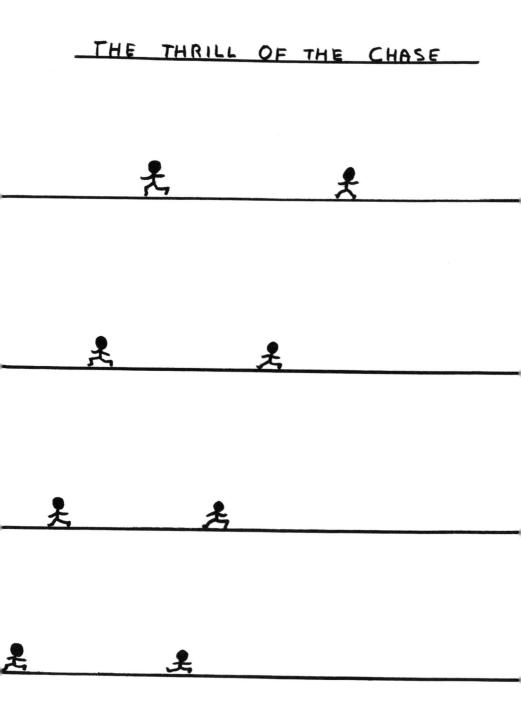

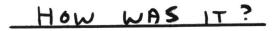

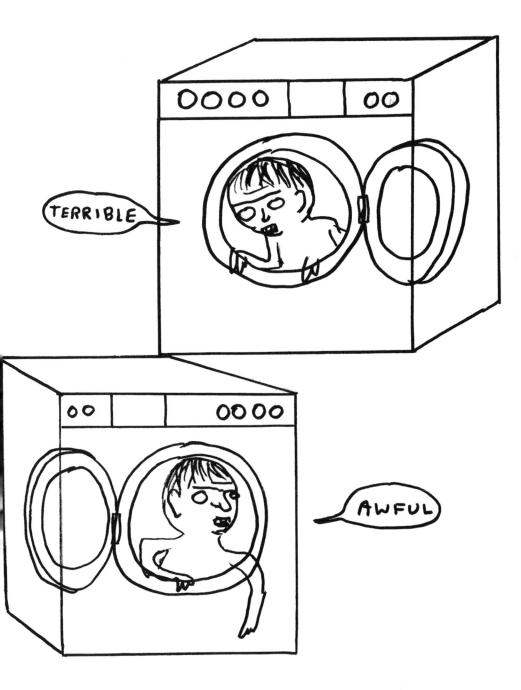

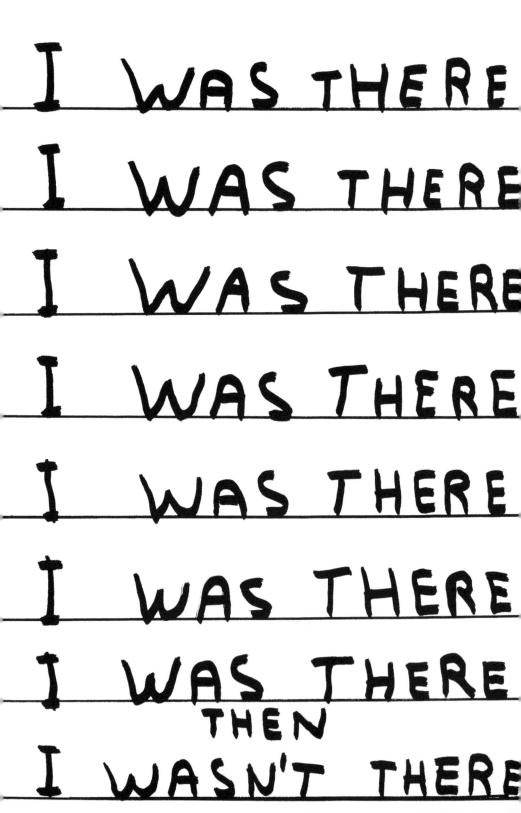

SIX SQAURES WITH WRITING

SOME

WITH WRITING

SOME

NITHOUT WRITING

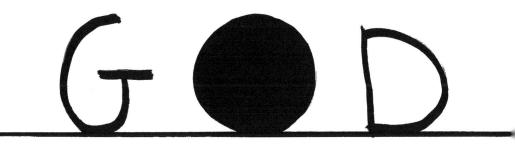

GRAVES

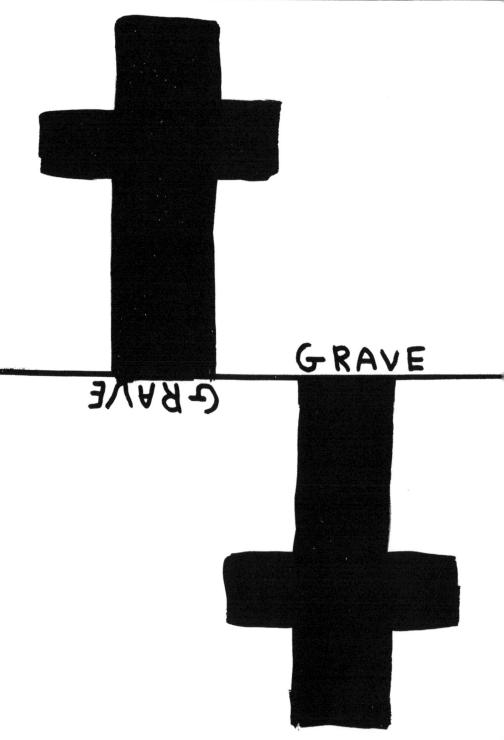

DENSE

INSTITUTIONS BUILT ON A SLOPE

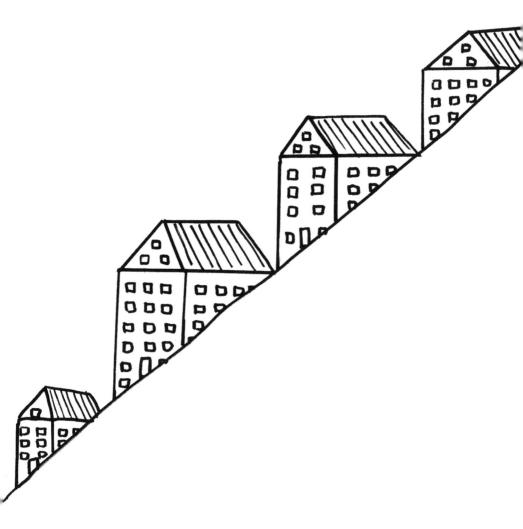

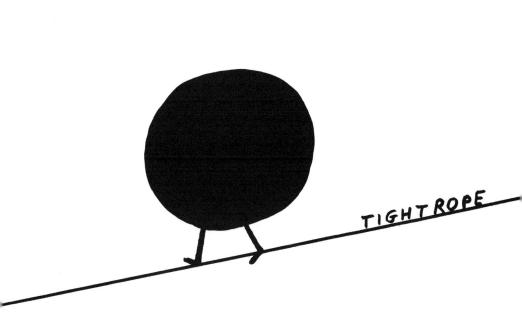

SHIT

SOMETIMES I WISH I WAS A POLICEMAN

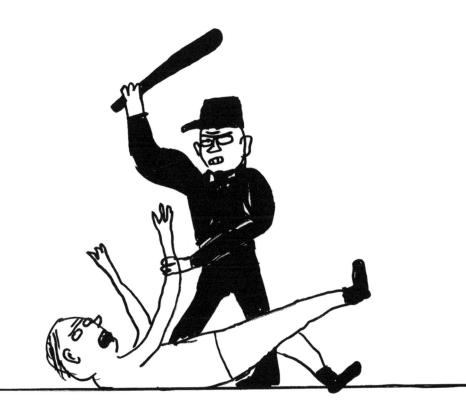

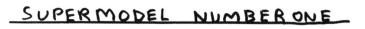

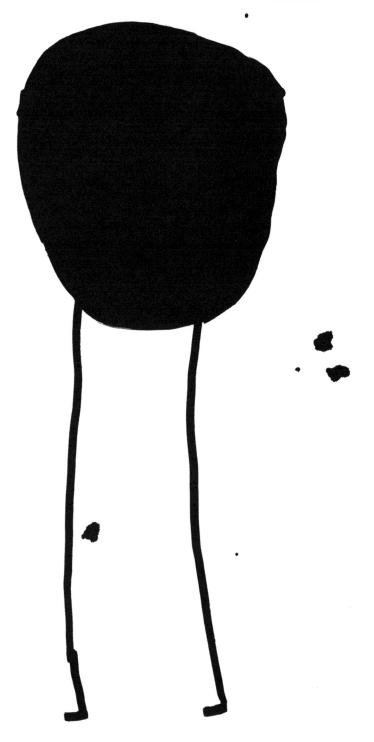

SUPERMODEL NUMBER TWO

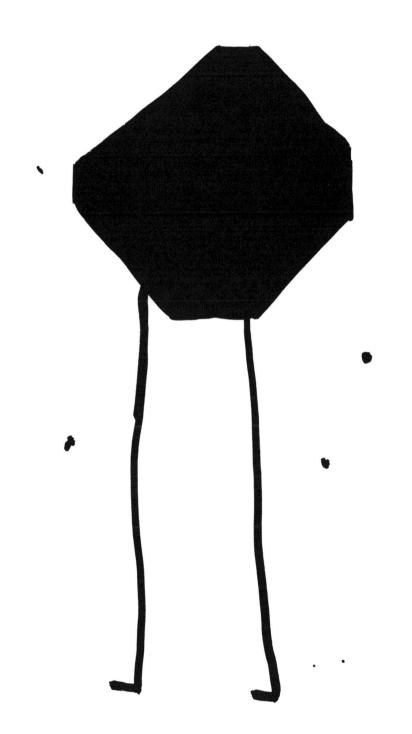

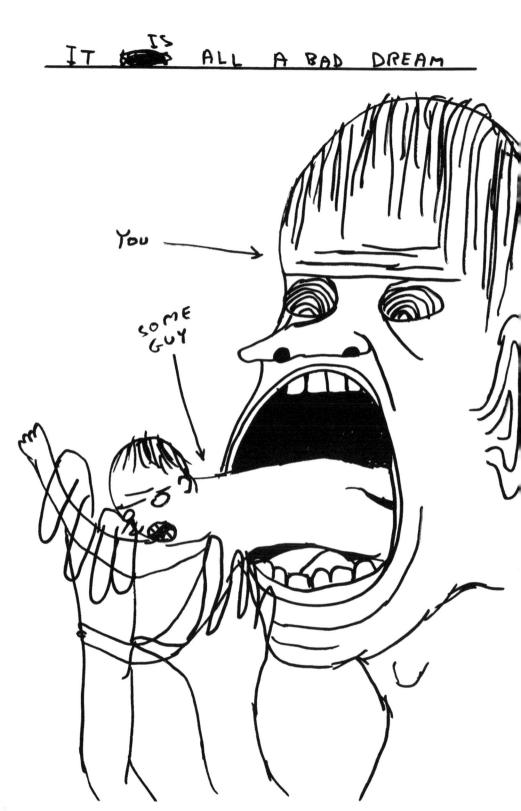

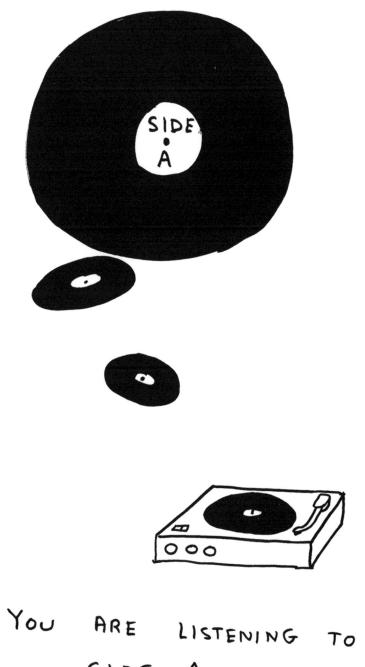

YOU HAVE BEEN LISTENING TO SIDEA FOR YOUR WHOLE LIFE

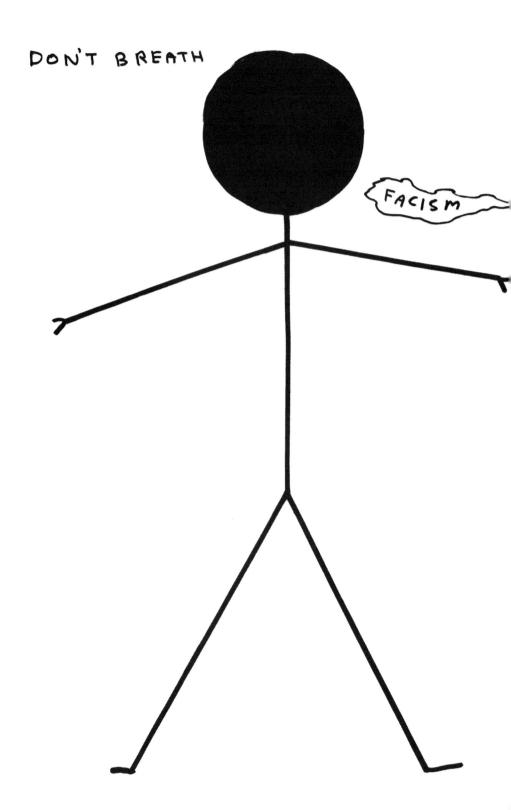

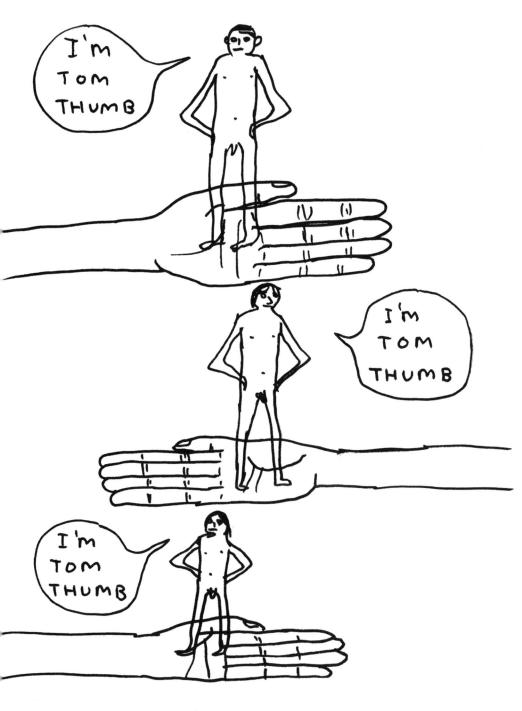

THEY CAN'T ALL BE TOM THUMB TWO OF THEM ARE LIARS

PLAYING HAPPILY

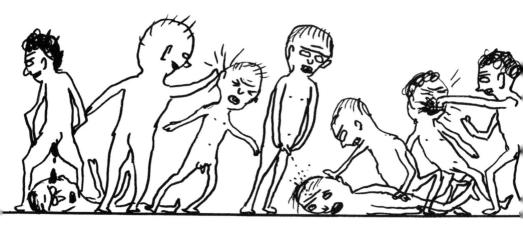

THEN THE NEXT MOMENT THE COMET STRUCK AND THEY WERE ALL DEAD.

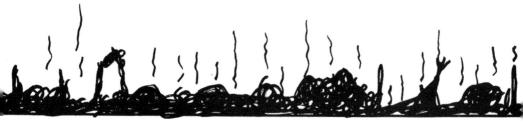

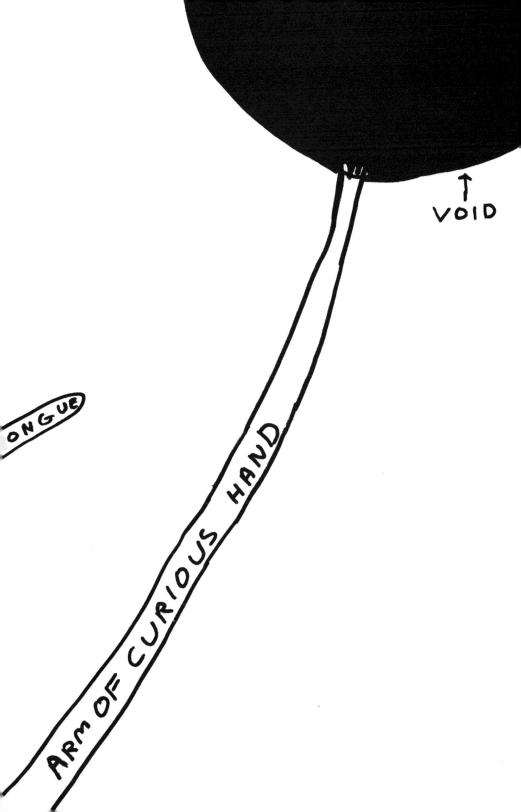

THE BEST

VERY LITTLE DIFFERENCE BETWEEN THEM

THE WORST

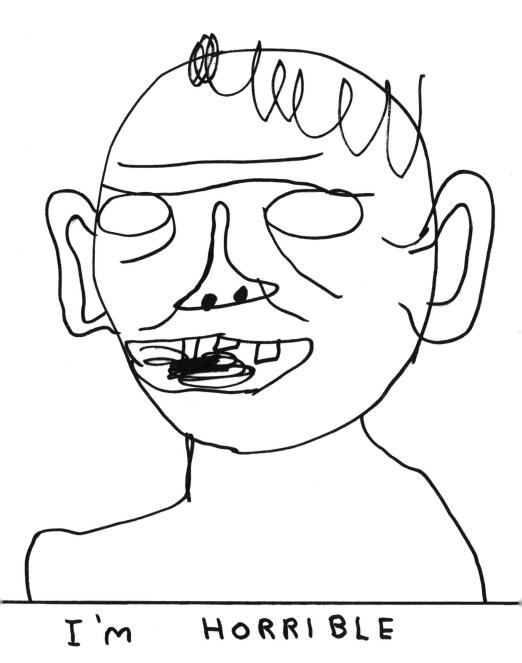

TIP OF MY PENCIL

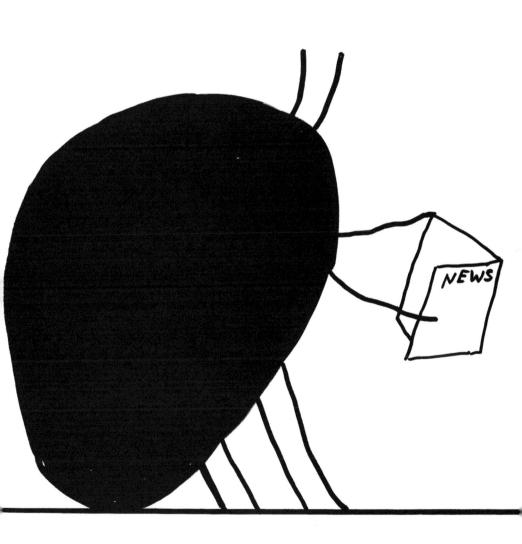

APPROACHING THE RUNWAY

LANDED

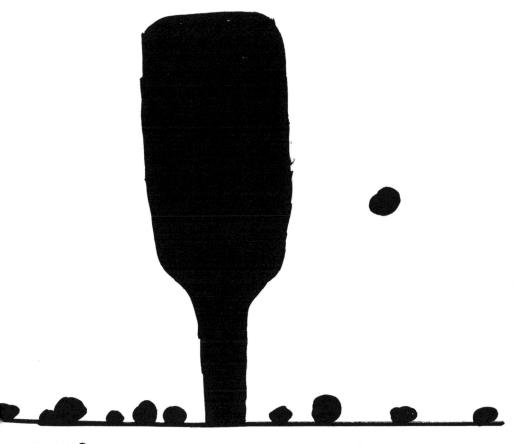

THREW THE STONES MISSED THE BOTTLE HIT A DOG

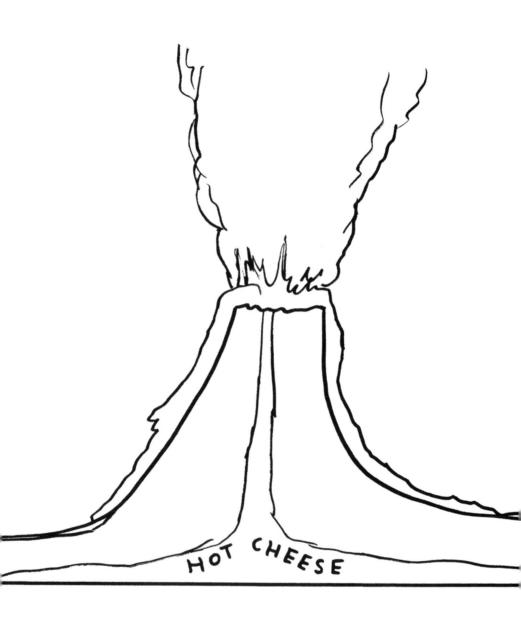

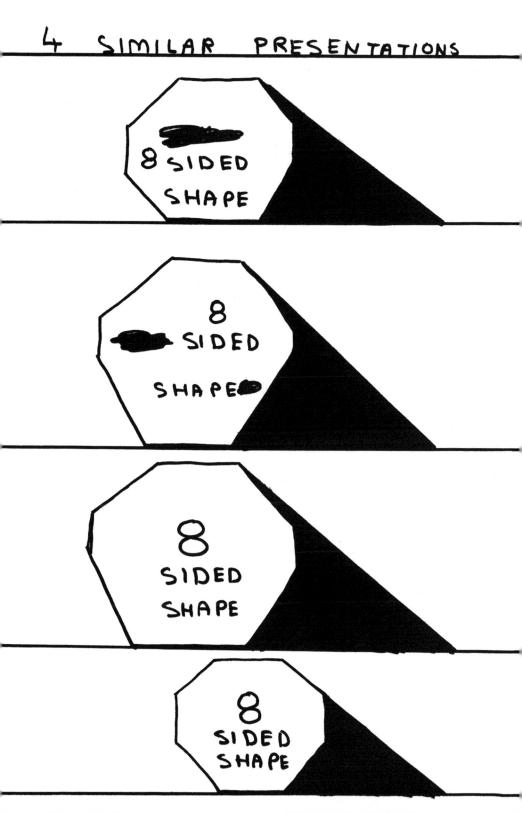

THE START	THE RACE HAS STARTED	I AM WINNING
YOU ARE LOSING	NOW J AM EVEN FURTHER AHEAD	YOU ARE SO FAR BEHIND
IT'S GETTING EMBARA SSING	YOU ARE BEING HUMILIATED	THIS ISN'T ENJOYABL
LET'S STOP THE RACE HERE		

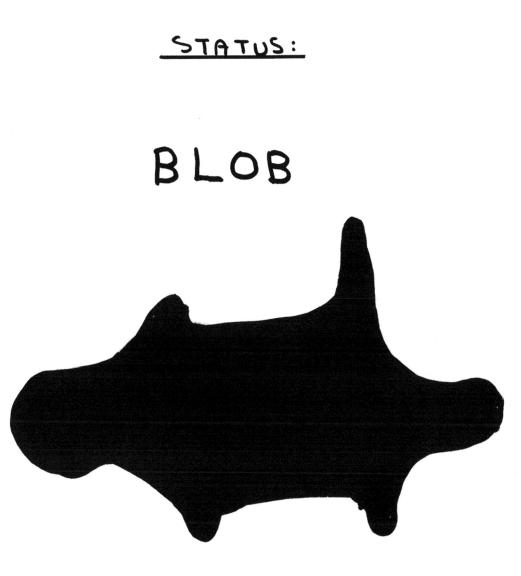

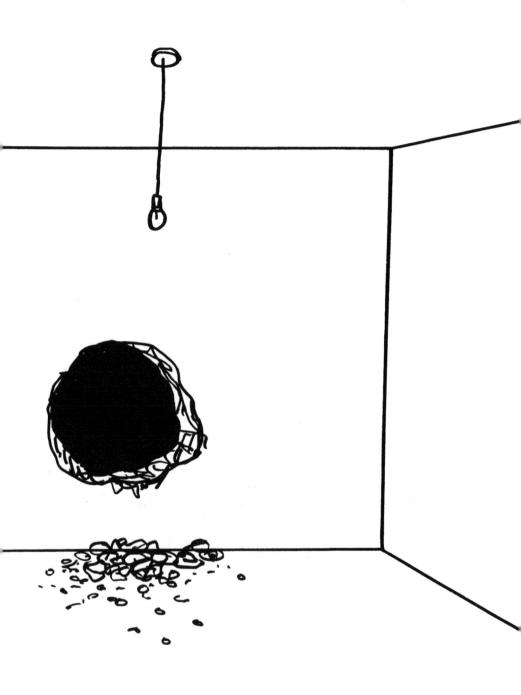

HOLE IN YOUR WALL

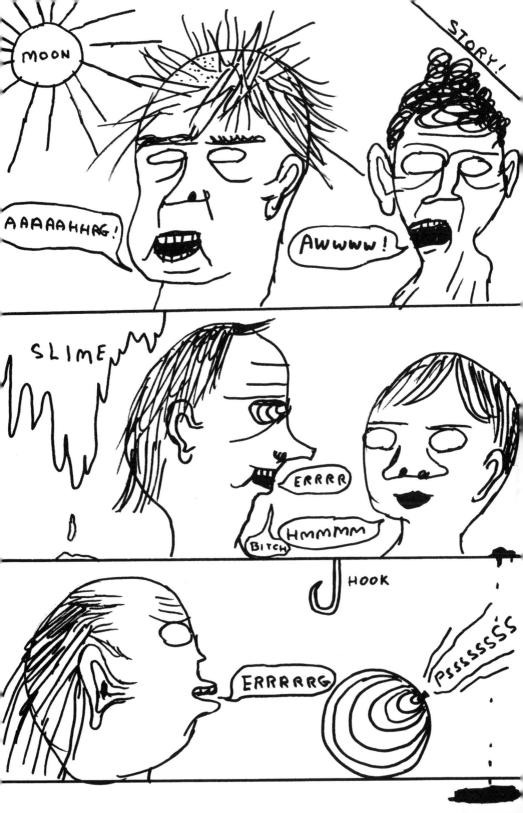

UNTALKATIVE YOUTH WILL BE YOUR GUIDE ON YOUR FINAL JOURNEY

ARRIVAL IN NETHER WORLD

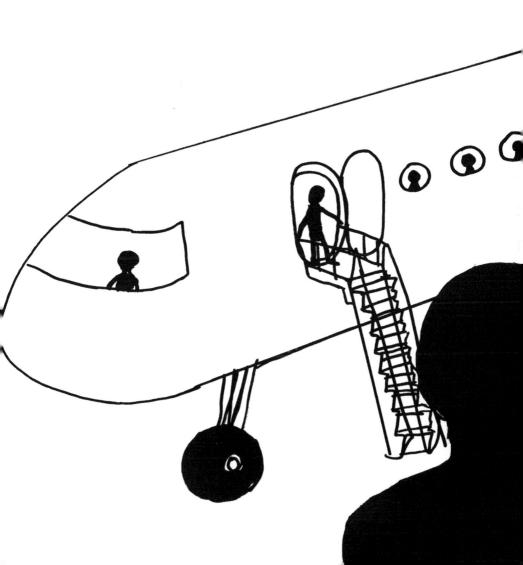

SEE	IT	?		
NO				
ARE	You		BLIND	?
YES				

THINKING ABOUT LEAVING THE STAGE

HAVING DECIDED NOT TO LEAVE THE STAGE BUT HAVING BEEN FORCED TO DO SO BY OTHERS

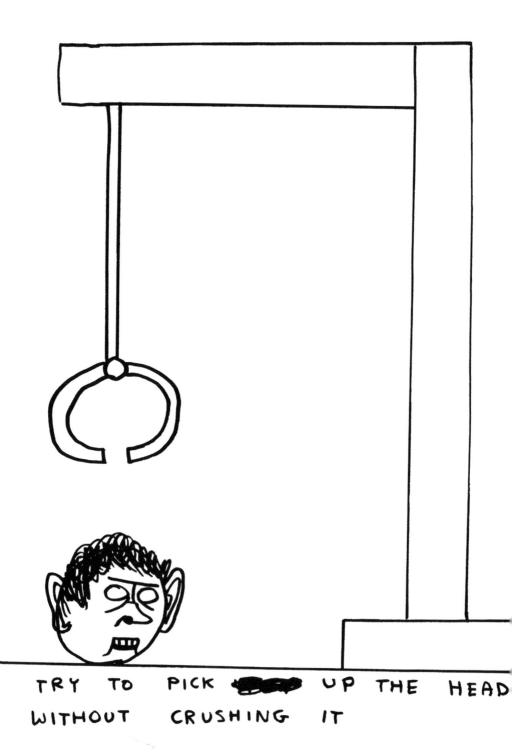

NO WAY

BUT WE WON'T LET IT FALL DOWN

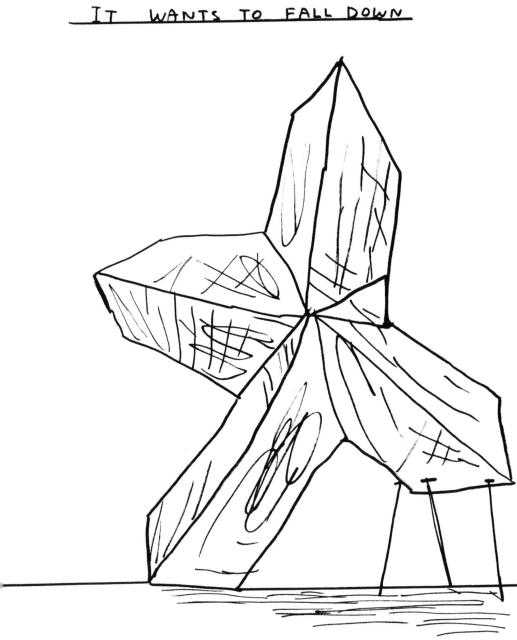

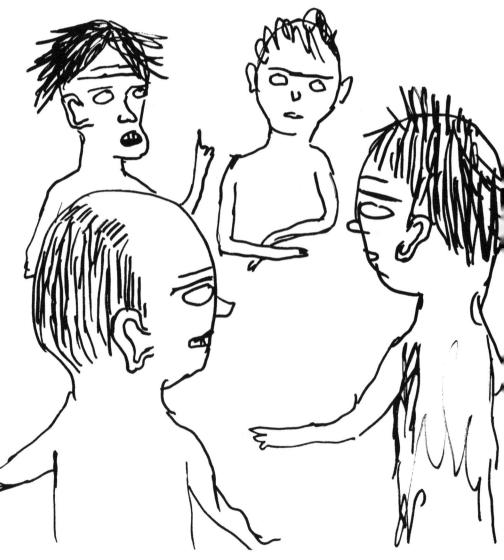

ME

AM AN ISLAND IN THE OCEAN

NO SHIPS ARE ALLOWED TO VISIT ME

I AM WINDSWEPT

I HAVE A CAVE

I HAVE TREES

AM DESERTED OF PEOPLE

I AM INHABITED SOLELY BY RATS

I AM VERY REMOTE

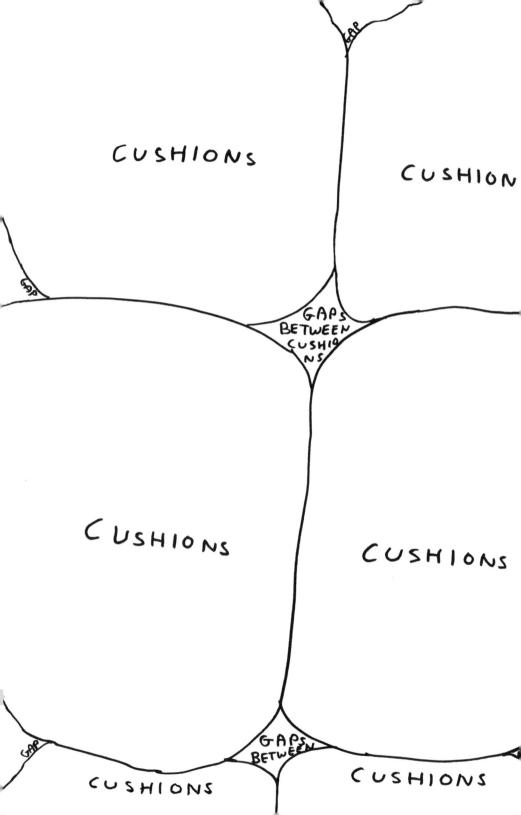

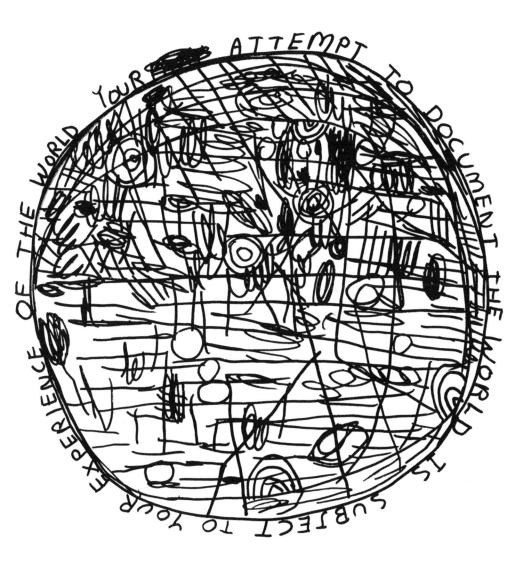

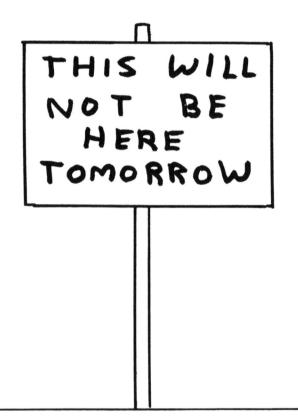

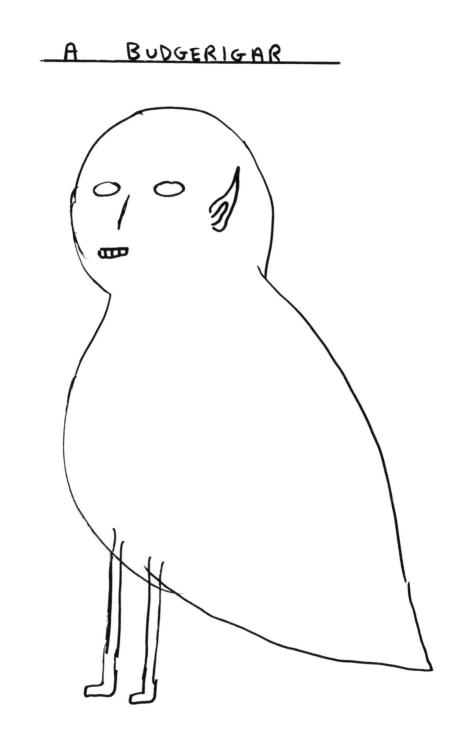

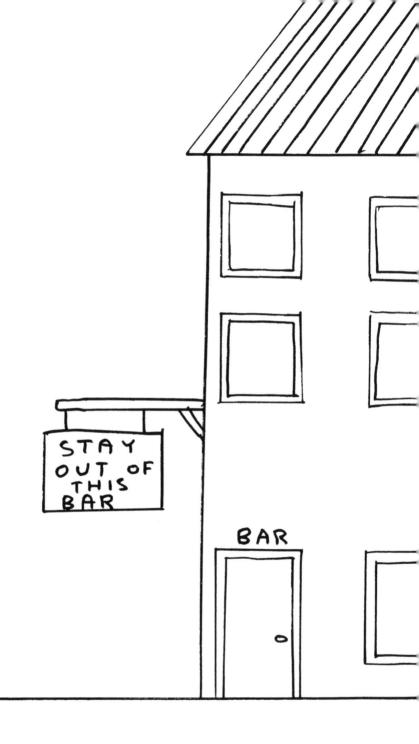

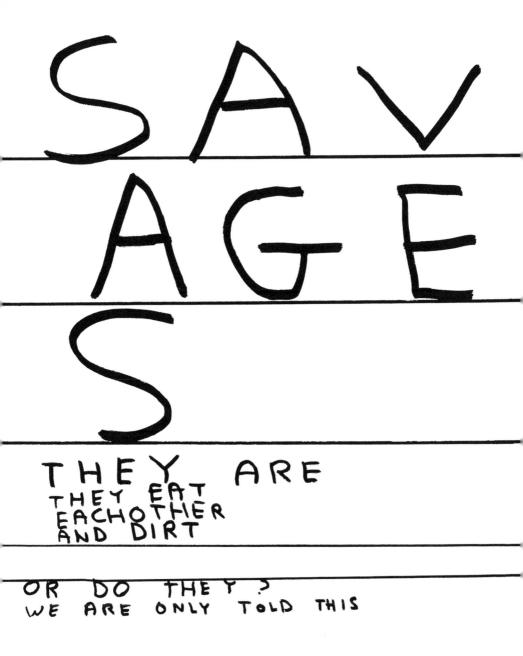

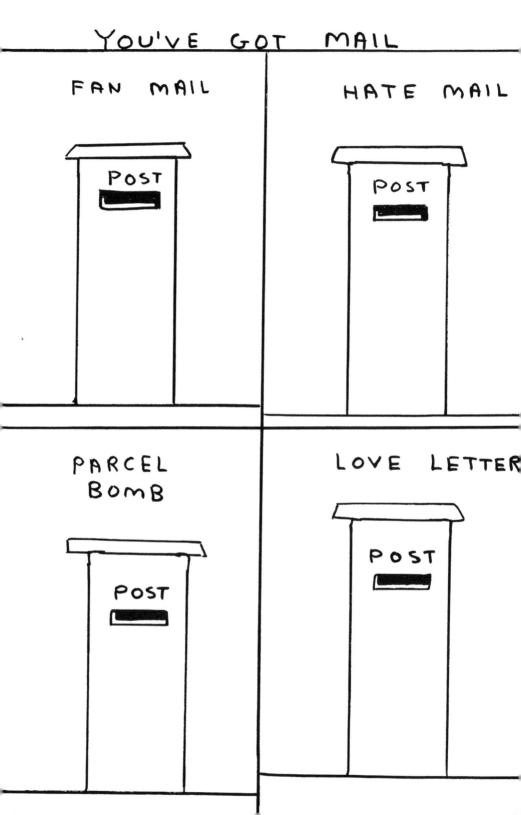

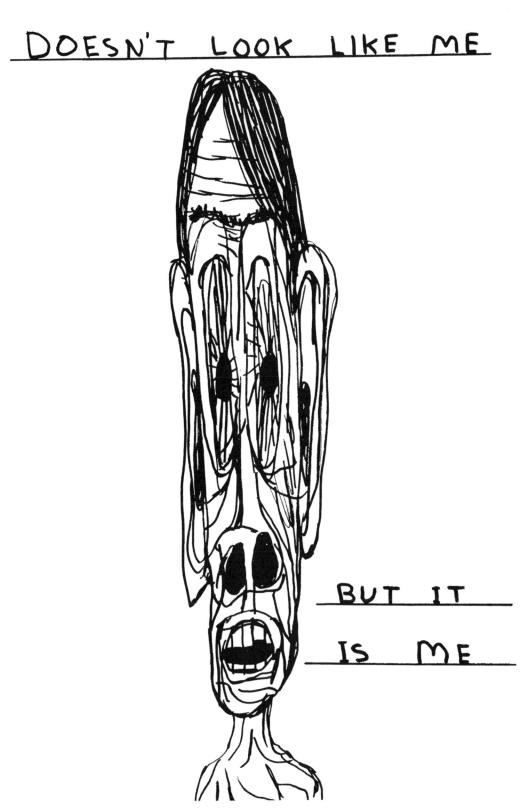

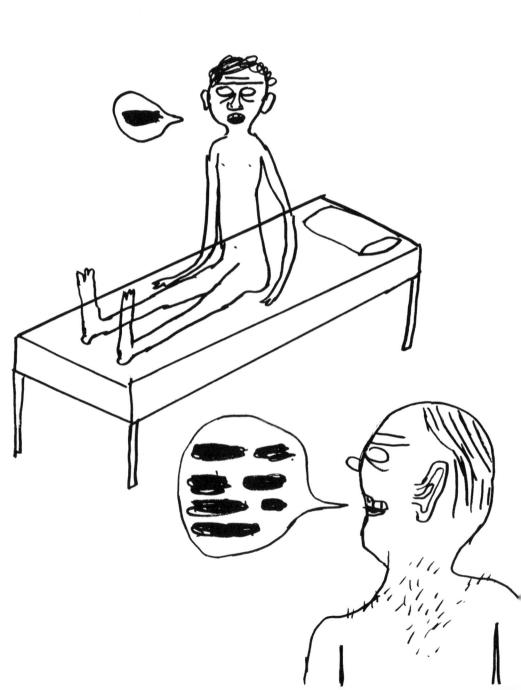

EVERYTHING WILL BE COVERED

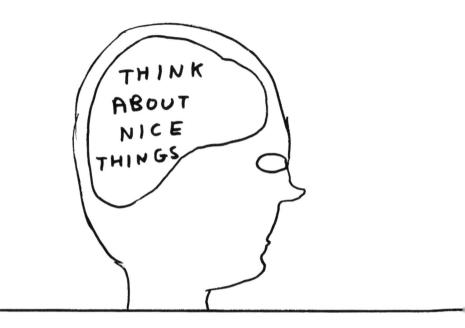

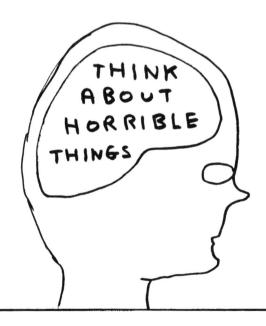

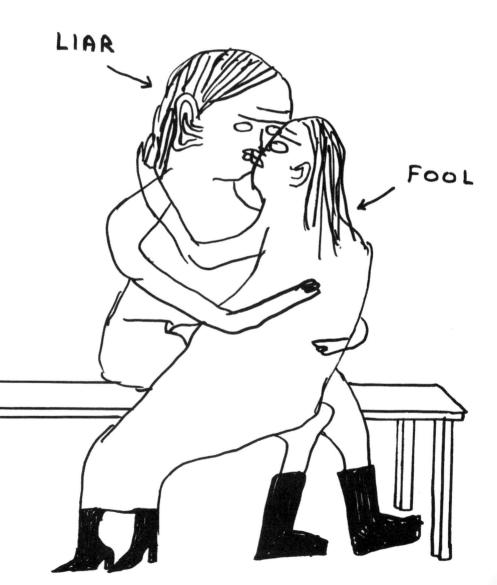

LAKE OF SOUP

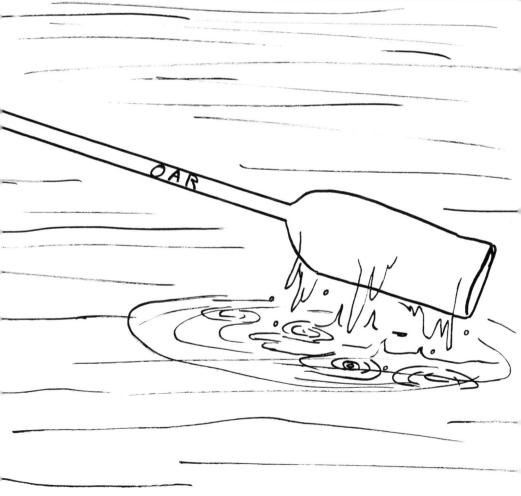

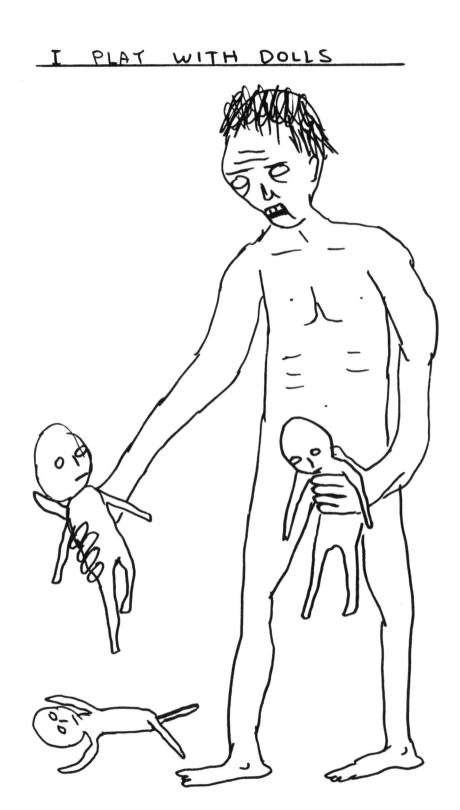

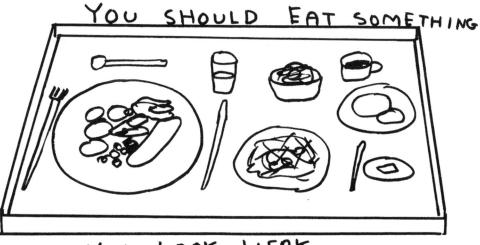

YOU LOOK WEAK

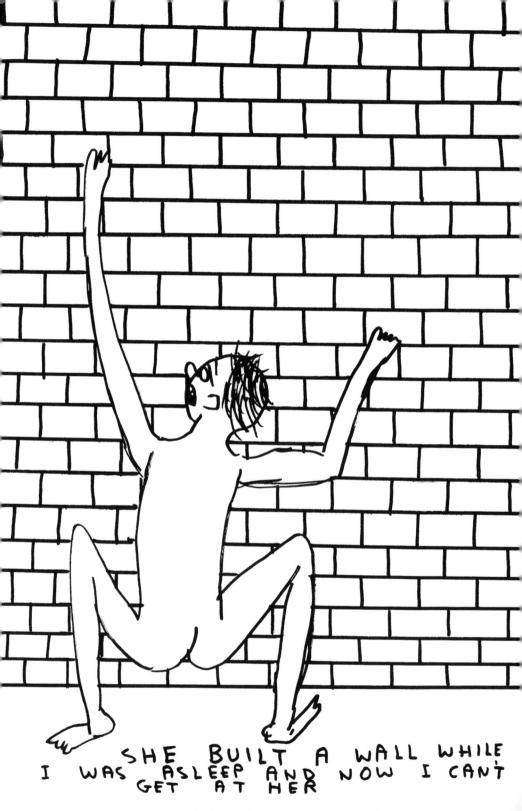

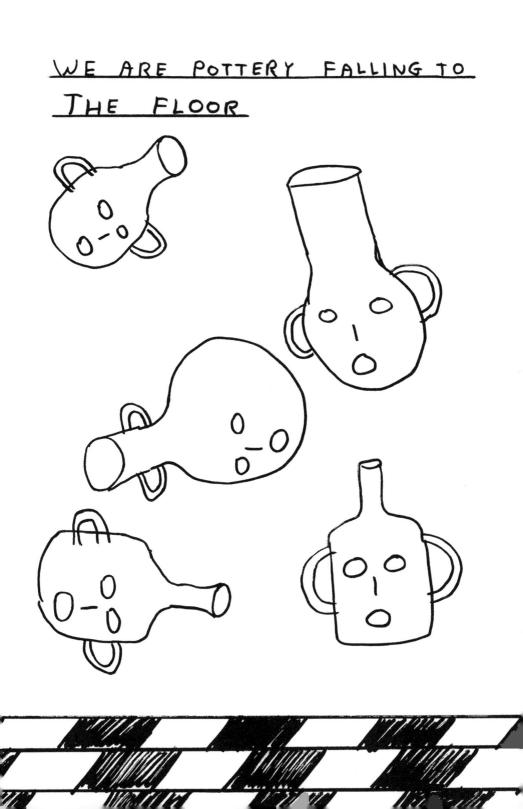

GIVE THE MIDGET A WEAPON

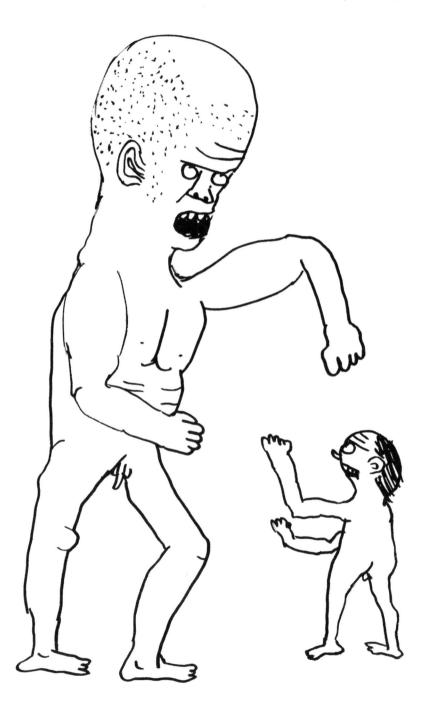

FOUR

I LOOK AT IT ALL DAY LONG AND I ALSO LOOK AT IT AT NIGHT

HAIRS GROW ON DEAD ARM

IICEBBERG ISA SYMBBOL ICEBERGISSASSYMBOL ICEBERG IS A SYMBOLFOR ICEBEBERGIS A SYMBOLFOR ICEBERGISA SYMBOLFOR THECHAOS THECHAOSTHATIS ICEBERGISA SYMBOLFOR THECHAO SYMBOLFOR THECHAOS THATIS ABOUTTOCOME

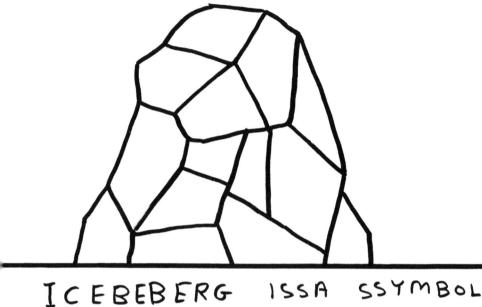

BEING DRUNK IS GREAT

INTERESTING LIFE

BORING LIFE

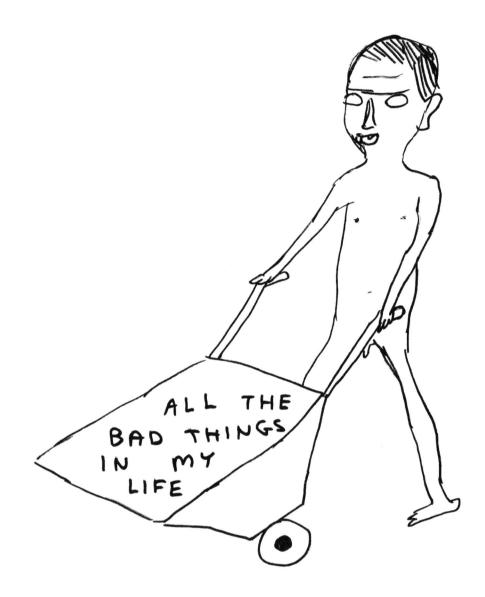

I'M GOING TO BURY THEM IN THE GARDEN

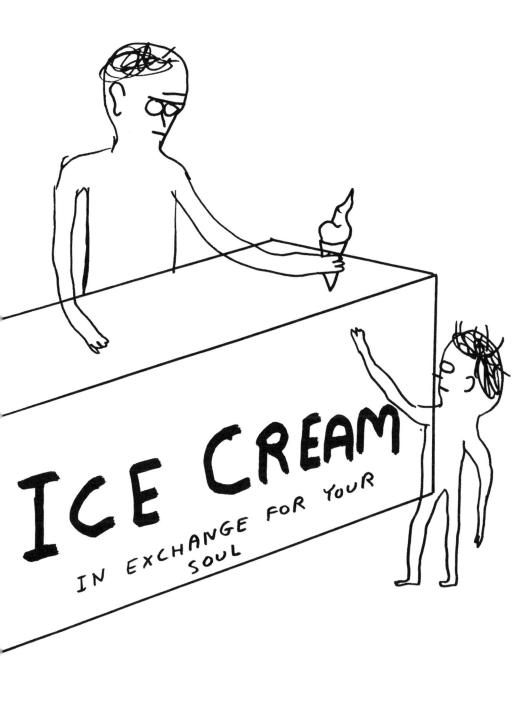

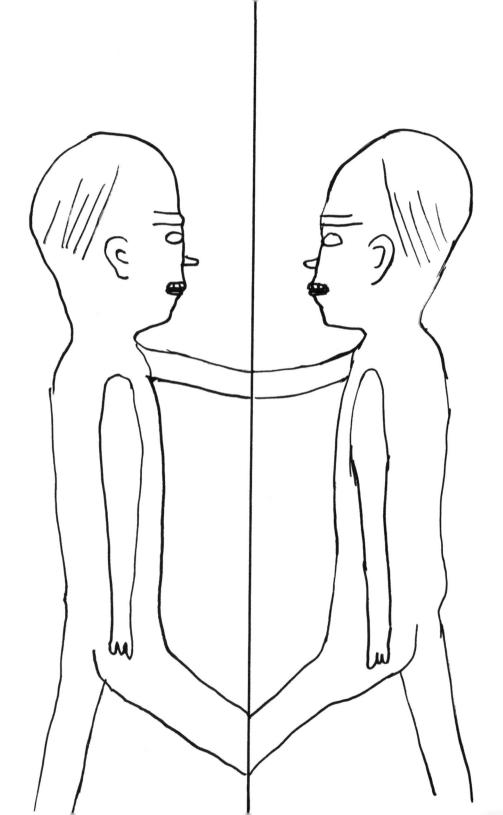

OPERATED UPON BY CHILDREN

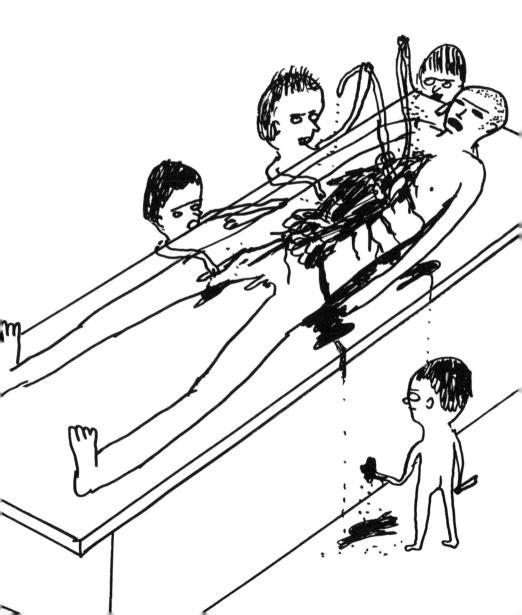

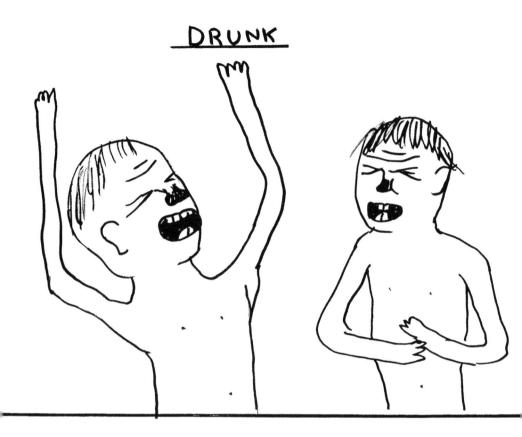

SOBER

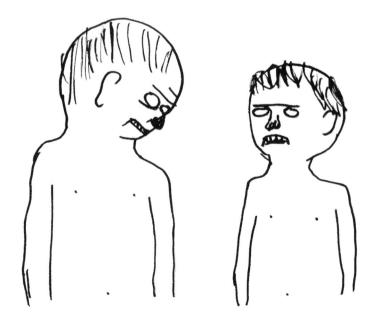

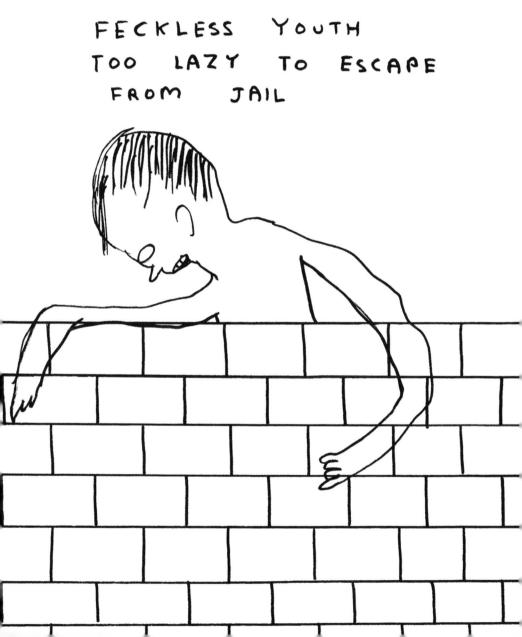

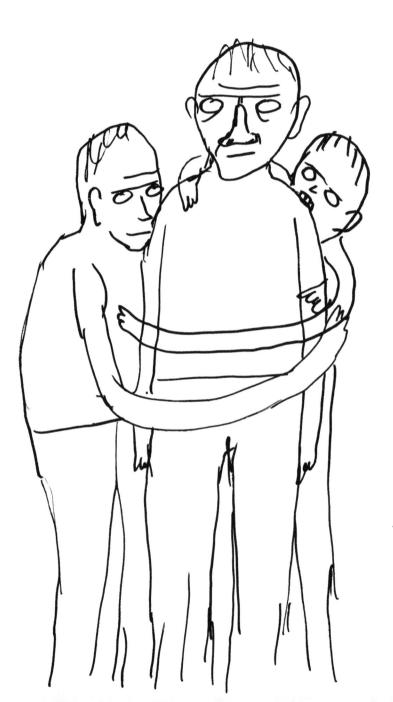

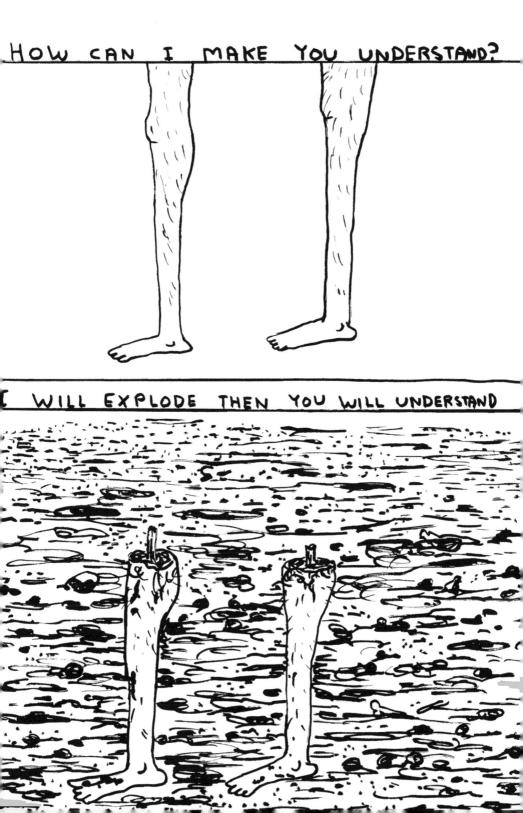

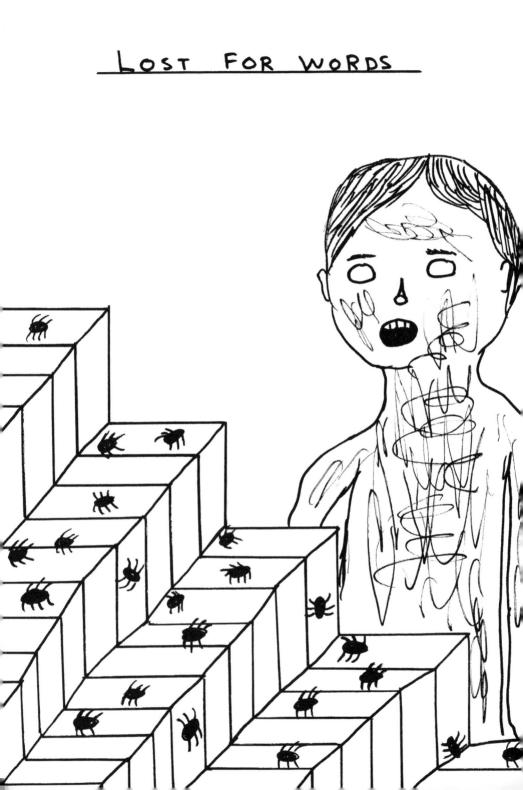

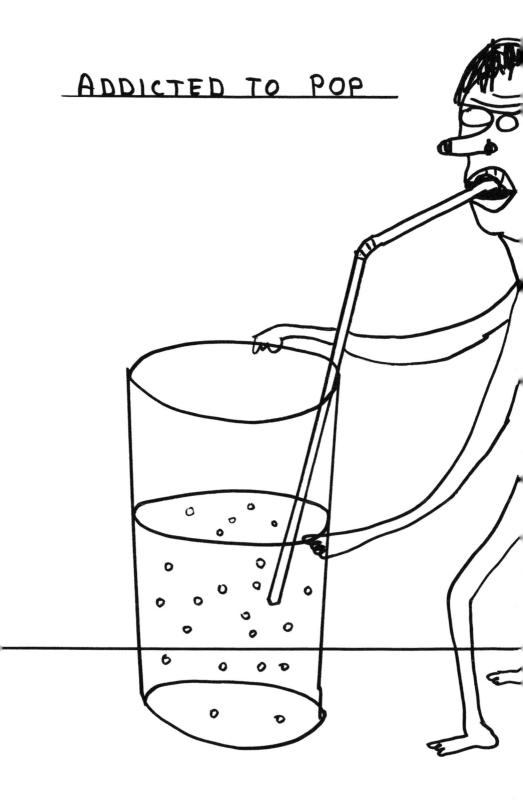

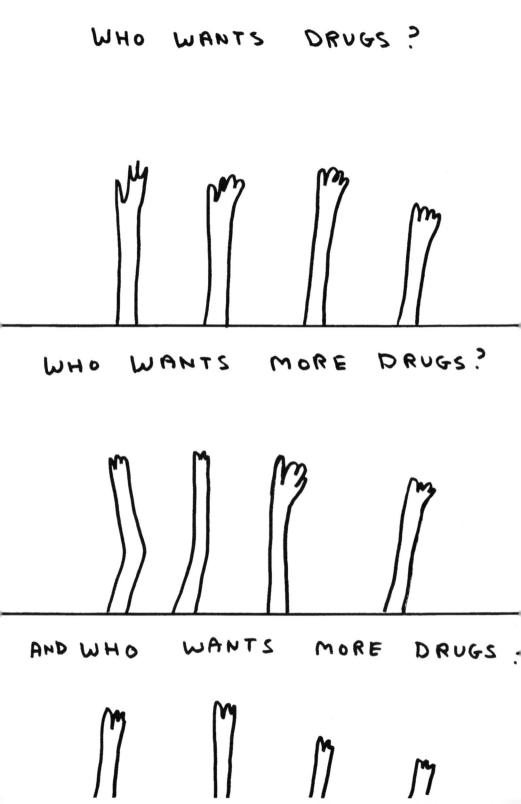

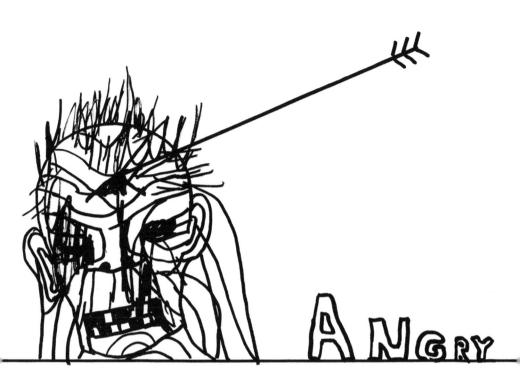

BECAUSE OF THE ARROW

I FLICK A SWITCH AND

SEE HOW THE TERRIBLE

ATMOSPHERE GOES AWAY

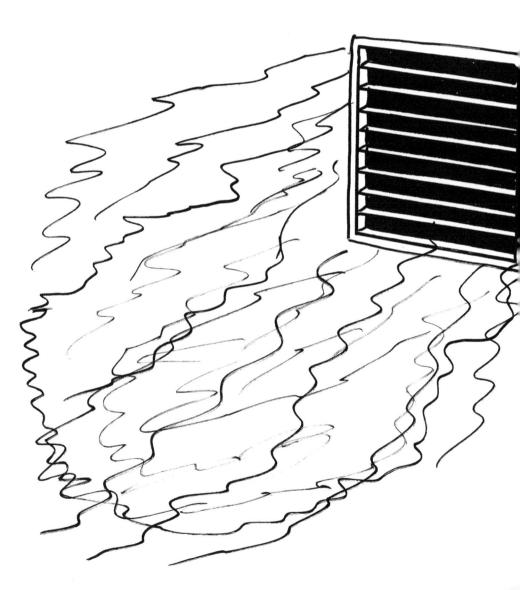

A MISTAKE THAT ANYONE COULD MAKE

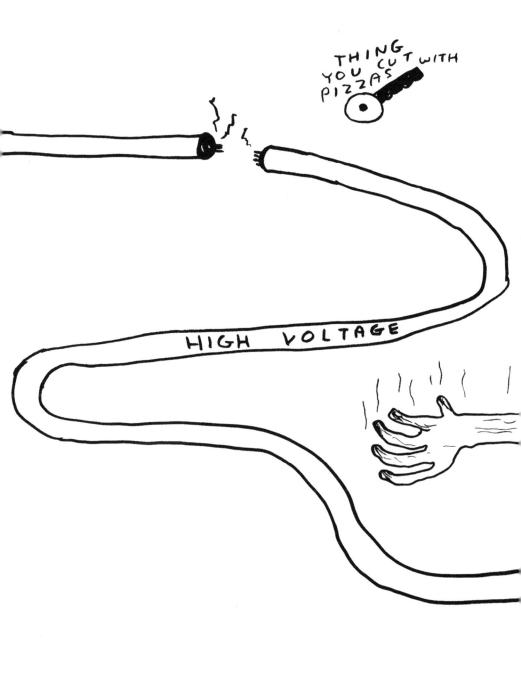

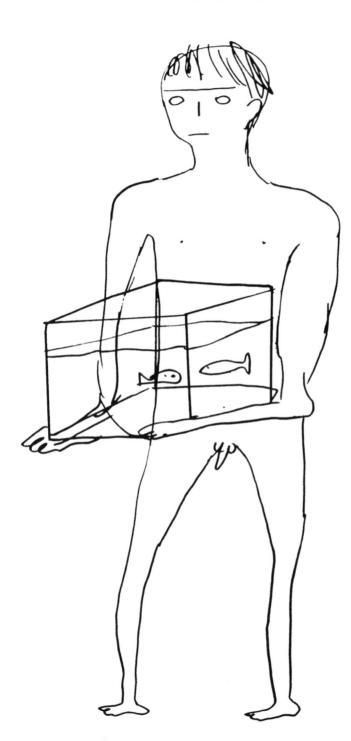

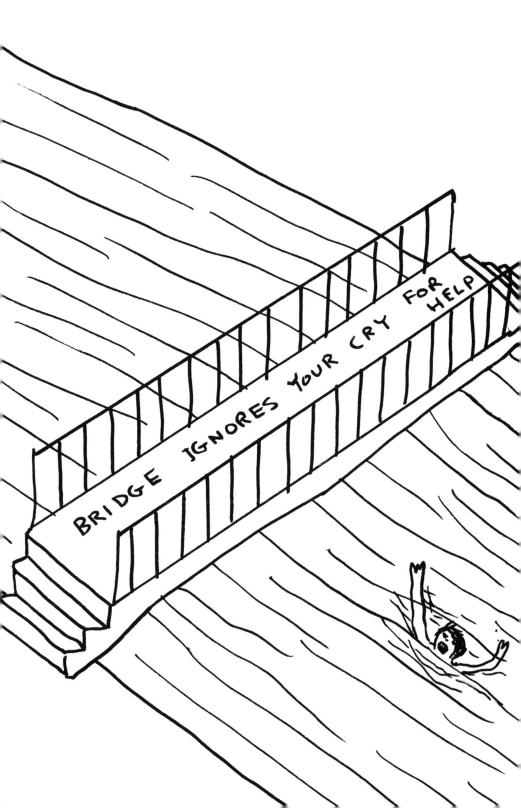

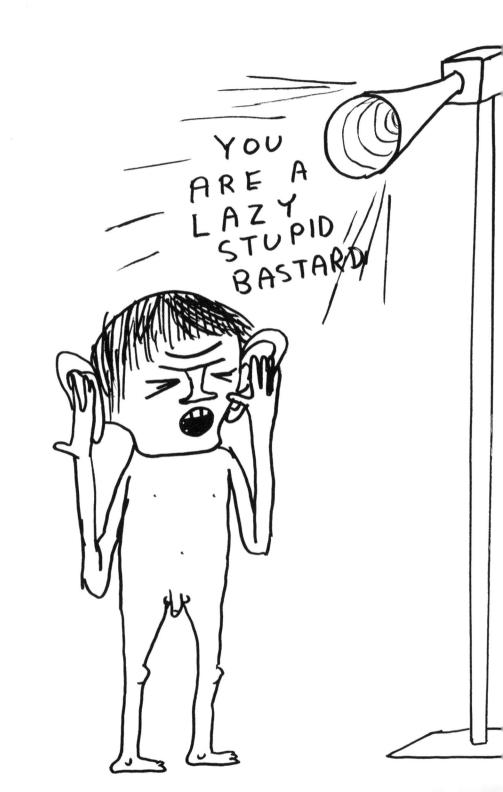

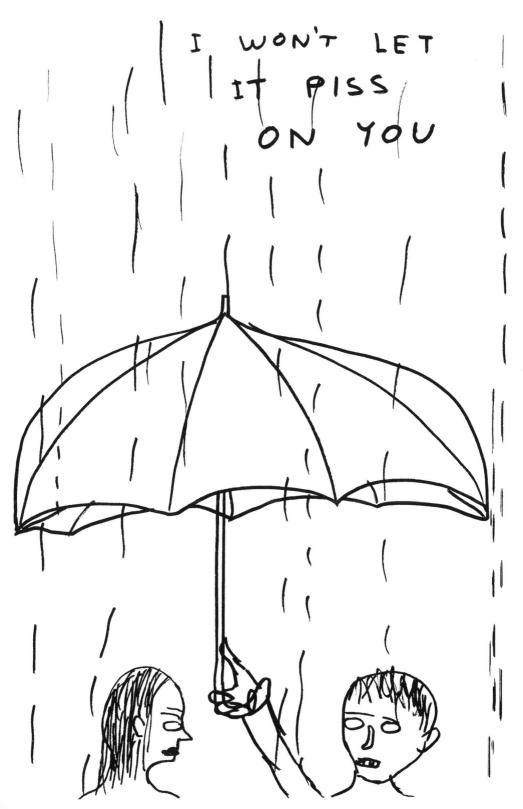

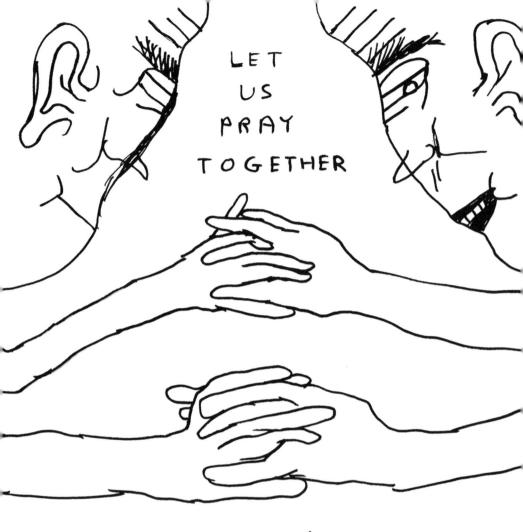

NO! WAIT !

STOP THE PRAYER !

I FORGOT TO TURN OFF

THE OVEN

THEN FUCK OFF

THANK - YOU !

YOU'RE WELCOME !

FLATTENED

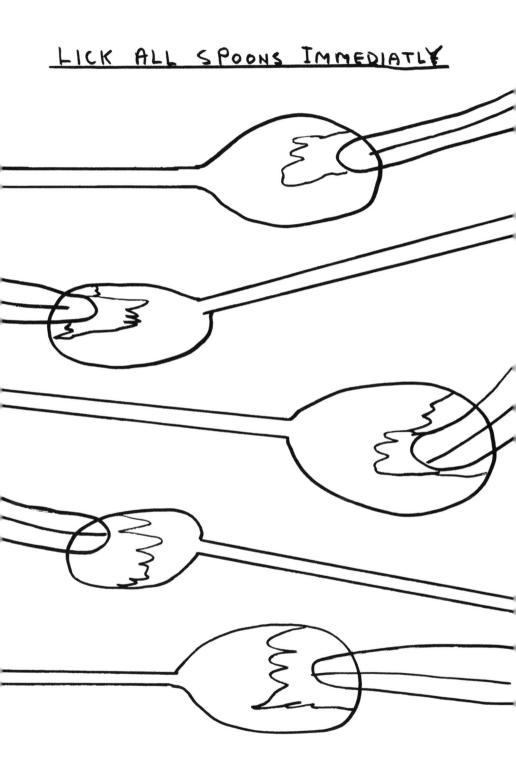

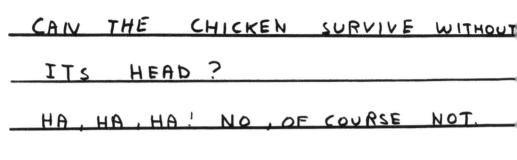

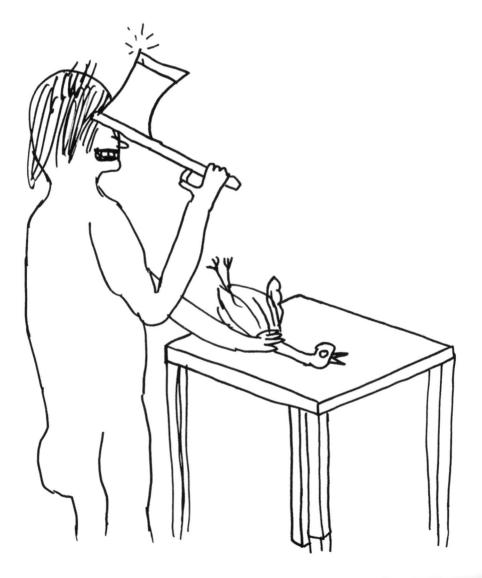

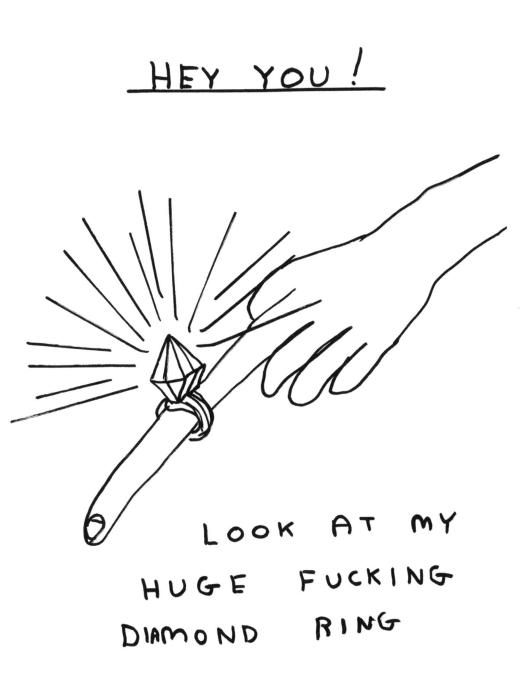

MEAT SHOP

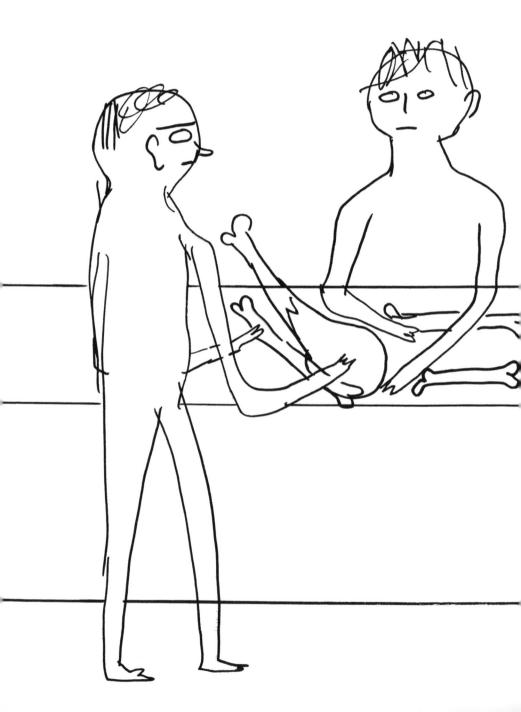

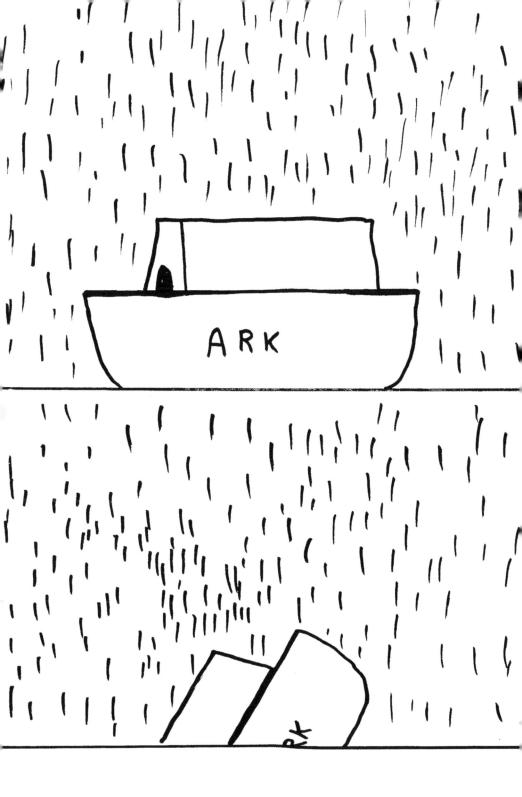

WHEN I WAS A BOY I WANTED TO BE A VAGRANT AND NOW I AM A VAGRANT

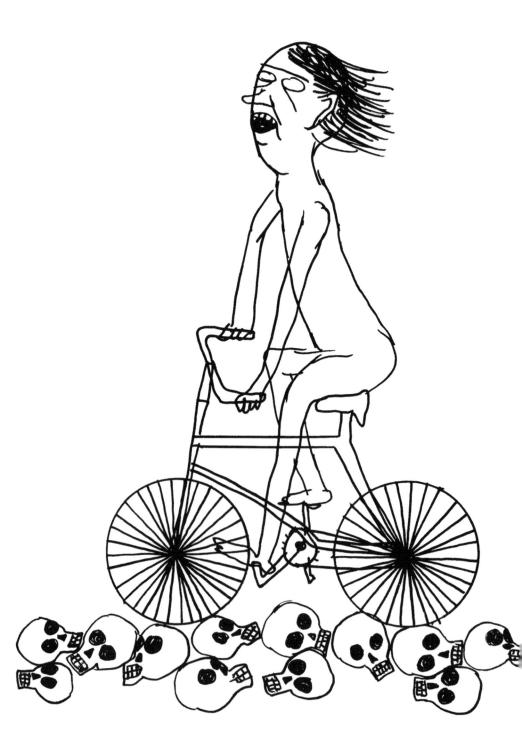

COOKING NOTHING

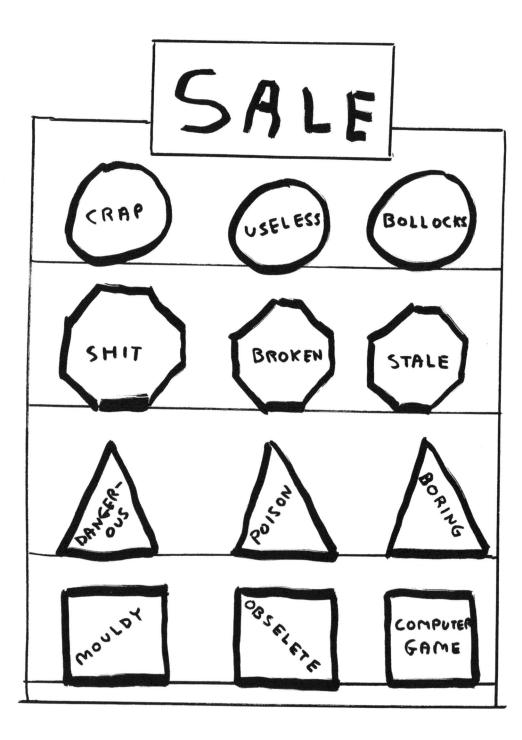

I WENT TO SLEEP AS A BABY AND I WOKE UP AS AN OLD MAN HOW DID IT HAPPEN ?

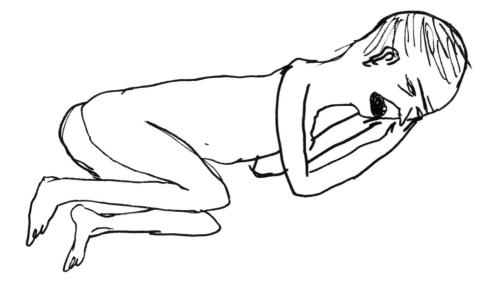

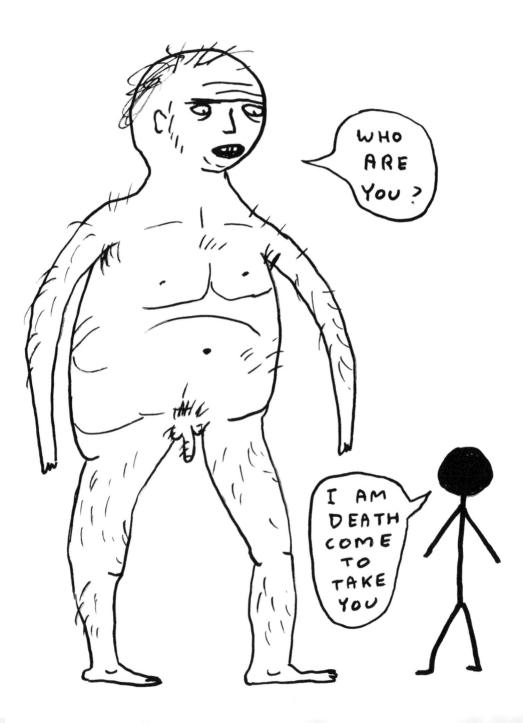

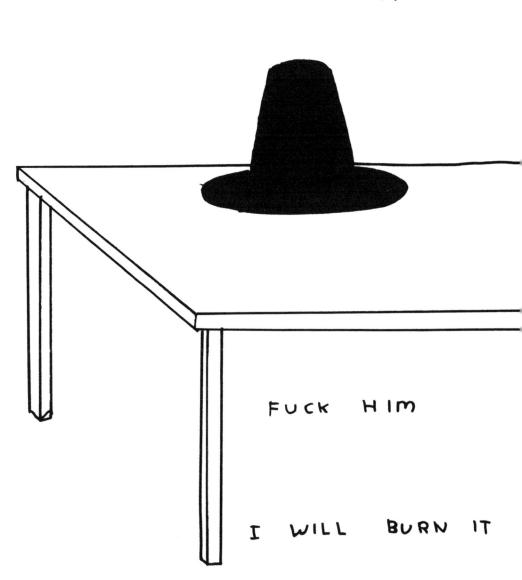

HE LEFT HIS HAT

RECIPE FOR CONCRETE

- 234 PARTS STONE & GRAVEL
 - 2 1 PARTS SAND
 - 1 PART CEMENT
 - 1/2 PART WATER
 - 1 PART LOVE

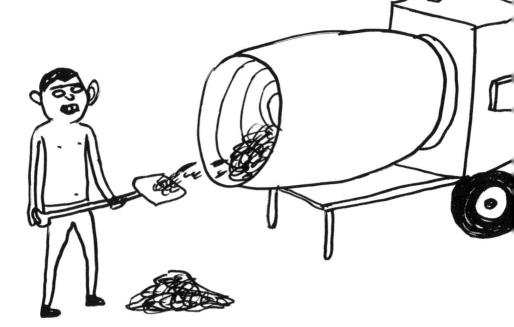

YOU HAVE ARRIVED AT YOUR DESTINATION

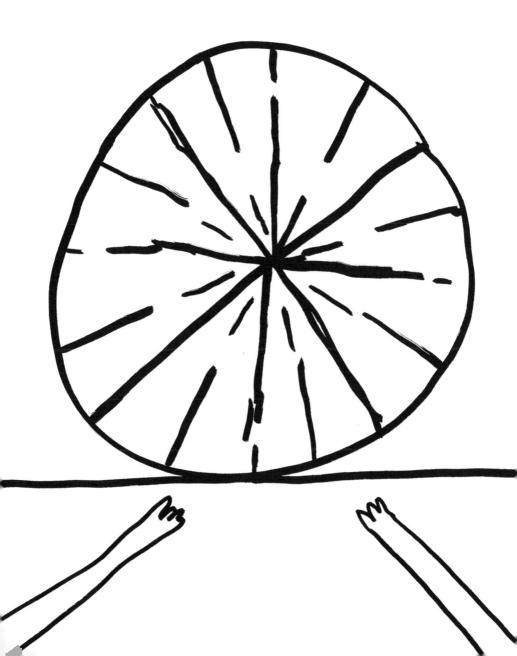

TURN OUT THE LIGHT